MODERN ARTISTS

First published 2011 by order of the Tate Trustees
by Tate Publishing, a division of Tate Enterprises Ltd,
Millbank, London SW1P 4RG
www.tate.org.uk/publishing
© Tate 2011

A catalogue record for this book is available from the
British Library
ISBN 978 1 85437 912 2
Distributed in the United States and Canada by
Harry N. Abrams, Inc., New York
Library of Congress Control Number: 2010931938
Designed by Mr & Mrs Smith
Colour reproduction by Altaimage, London
Printed in Hong Kong by Printing Express

Mixed Sources
Product group from well-managed
forests, and other controlled sources
www.fsc.org Cert no. SGS-COC-002987
© 1996 Forest Stewardship Council
FSC

Front cover (fig.28, detail) and previous page:
CARAMBOLE WITH PENDULUM 1996

Overleaf: PROTOTYPE 2004 (detail)
Synthetic polymer paint on canvas
50 x 50

All works and words by Gabriel Orozco are
© Gabriel Orozco
All images are courtesy of the artist; Marian Goodman
Gallery, New York; Galerie Chantal Crousel, Paris; and
kurimanzutto, Mexico City unless otherwise indicated.

Measurements of artworks are given in centimetres, height
before width before depth, unless stated otherwise.

Jessica Morgan is The Daskalopoulos Curator,
International Art, Tate Modern

Author's acknowedgements

First and foremost I would like to thank Gabriel Orozco.
His commitment and good humour throughout was
exceptional given the demands on his time, and especially
admirable considering his concurrent retrospective.
The staff at Marian Goodman are exemplary – including
Linda Pellegrini, Andrew Richards, and Catherine Belloy –
and together with Jose Kuri and Monica Manzutto of
kurimanzutto, Chantal Crousel and Niklas Svennung
of Galerie Chantal Crousel, made this book a pleasure to
produce. I am indebted to Lewis Biggs for his insightful
comments, to Nicola Bion for her patience, and to the other
members of the publishing team: Vicky Fox, Silke Klinnert,
Roanne Marner, and Linda Schofield. Finally, thanks go as
always to Ulrich and Konrad.

Artist's acknowedgements

I would like to thank Jessica Morgan, Vicente Todolí, Ann
Temkin, Paulina Pobocha, Mendes Burghi, Christine Macel,
Maria Gutierrez, Simon Orozco, Marian Goodman, Chantal
Crousel, Monica Manzutto, Jose Kuri, Andrew Richards,
Elaine Budin, Catherine Belloy, Roger Griffin, Kerry
McGinnity, Amelia Hinojosa, Colin Hamilton, Kulgin Duvall,
Benjamin Buchloh, Briony Fer, Niklas Sevennung, Jay Joplin,
Sussannah Hyman, Johanna Winstrom, Agnes Fierobe, Lynn
and Evelyn de Rothschild, Philipe Picoli, Grazia Cattaneo,
Juan Carlos Martin and Luisa Saenz. I am deeply grateful for
their love and support over the years.

GABRIEL OROZCO

Jessica Morgan

Tate Publishing

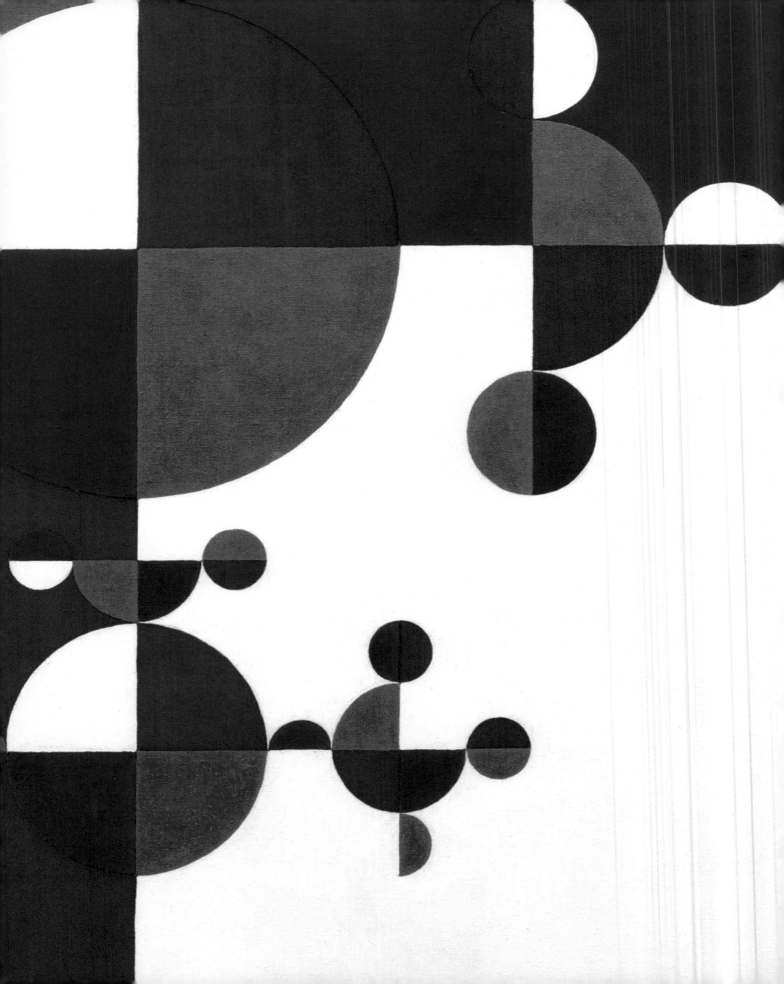

CEMETERY (VIEW II) 2002 [1]
Chromogenic colour print
40.6 x 50.08 Edition of 5
85.73 x 118.75 Edition of 3

INTRODUCTION

There is no such thing as a material without history. It doesn't exist. Every material has history. And in a way, everything is already a product. Even if you have a piece of stone in front of you somebody cut it out, somebody transported it, there is labour and investment already in every material you use.[1]

A sculptor of global significance since the 1990s, Gabriel Orozco is best known for the lightness of touch that he brings to the subtlest of gestures – breath's condensation on the black lacquer surface of a piano top – as well as the apparently grandiose – the slicing and shortening of a lift cabin. With minimal fuss and an apparently endless facility for making, Orozco manages to encapsulate in these works the pure pleasure of witnessing life (and the concomitant presence of death as a reminder of its frail significance), as well as an almost philosophical exploration of the making of the world: from the growth of trees to the movement of atoms and the construction of the universe. His most successful works contain this magnitude in nothing more substantial than the reflection in a puddle … or an empty open shoebox.

Casting aside the anxieties of his generation who were taught, in the wake of conceptual art of the 1960s and 1970s, to approach the making of objects with suspicion and the inclusion of narrative as outlawed, Orozco unhesitatingly cut and constructed, moulded and pressed, creating a body of work that over the years has incorporated industrial and fabricated objects, terracotta and paint; not to mention his endless experimentation with found objects, both natural and manmade, and detritus from the street, some of which has made its way into the gallery or museum while much has been discarded after an unfussy recording on camera. Expressing neither an ignorance of nor a wilful disinterest in art historical events, Orozco's return to particular artistic techniques and tendencies instead repositioned these actions within an intellectual as well as an intuitive framework.

This book examines Orozco's twenty years of work, identifying the consistency with which he has returned to certain forms and themes and the boundless creativity that he has applied to the sites, objects and situations that he has encountered during this time.

STONES IN THE FENCE 1989 [2]
Silver dye bleach print
40.6 x 50.8
Edition of 5

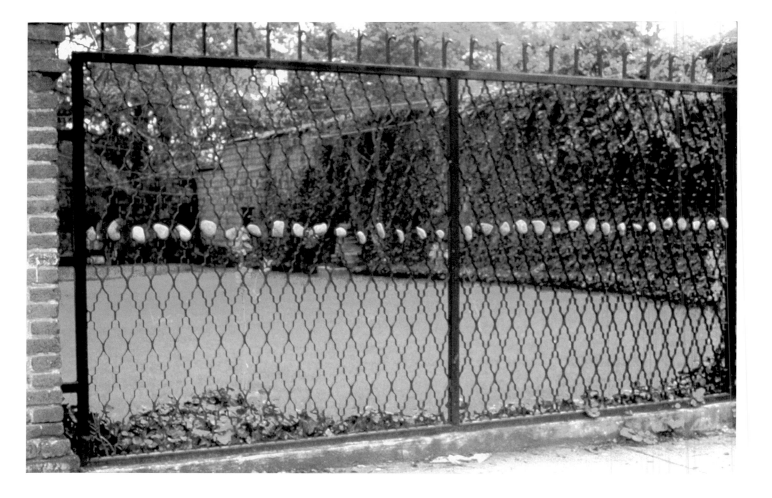

1

THE REAL THING

I got more and more distant from the idea of fantasy or surrealism in the work of art, which I found in the end ornamental or artificial. Surrealism was a very important trend in Mexican art through the twentieth century and I wanted to break with that. I wanted to break with the idea of attaching an object with special powers or psychological expression. One way to put it is that I was searching for realism. I was searching for the object as a thing that was real, not surreal.

Gabriel Orozco would identify 1986, the year he spent in Madrid as a student, as a formative moment in the development of his thinking as a mature artist. The art environment in Spain, which at that time was undergoing a post-Franco revival, introduced Orozco to the leading European practitioners of the day, as well as enabling a direct encounter with the work and ideas of conceptual and post-minimal art of Europe and the US. But perhaps as important as this expansion of his education was the unintentional exposure to or imposition of a form of second-class citizenship. Treated as a Mexican immigrant in Europe, Orozco was forced to examine his origins from a distance, re-evaluating the culture and upbringing from which he had emerged. He has credited this distancing with a significant mental shift that allowed him to occupy a new position, arguably one that has made him an exemplary figure within a generation of artists that first established what could be termed a global practice of art making. Orozco has said, reflecting on this period in Spain:

What's important is to be confronted deeply with another culture. And also to feel that I am the Other, not the resident. That I am the immigrant. I was displaced and in a country where the relationship with Latin America is conflicted. I came from a background that was very progressive. And then to travel to Spain and confront a very conservative society that also wanted to be very avant-garde *in the 1980s, but treated me as an immigrant, was shocking. That feeling of vulnerability was really important for developing my work. I think a lot of my work has to do with that type of exposure, to expose vulnerability and make that your strength. That's not so much to do with travelling, but displacement and intensity of being the Other. I think it's an experience that is very important to have not just for a week, it's not like a touristic experience, but to really emphasise that you are the Other, you are a foreigner, you are an immigrant.*

Orozco has always maintained that the movement that has been a feature of his existence from 1986 until recent years should not be referred to as nomadism (a term he considers too glamorous) nor should his status be identified with some new form of internationalism.[2] His travels are always with a purpose (to study, to join his girlfriend and later wife Maria Gutierrez on her studies and research, for the sake of an exhibition and so forth) and his engagement with the place in which he is situated is therefore of a different nature to the romantic wanderings of nineteenth-century artists or the ethnographic or touristic explorations of recent contemporaries. The impact of this experience has an effect not only on the relationship between Orozco and the place in which he is living but also on the relationship with his origins. What is most significant he states, is that 'when you are exposed to being the Other or being displaced, your relationship with your own background changes. You start to engage with your own culture in a different way, from a distance. Looking back to Mexico from afar I could see all of the uncomfortable feelings I have with Mexn art, with Mexican culture, with Mexican politics, everything.'

Prior to going to Madrid and the largely ephemeral work that he began to make there, Orozco had received an education in Mexico that was both experi-

mental, in so far as his parents – a third-generation muralist and a classical pianist – sent him to a progressive school, but also fairly conservative with regard to his art training at Escuela Nacional de Artes Plásticas (ENAP). His production consisted mainly of painting and drawing and examples from this time suggest clearly the influence of a local modernism. Orozco's move to Madrid entailed the loss of a large studio space and this contraction in his immediate surroundings was in part a further inducement, in addition to his awakening to another artistic language, to abandon the space-demanding activity of painting for a new medium. Exposed in Madrid and during the European travels he made while based there to the sculpture of post-minimalists such as Eva Hesse (1936–1970) and Bruce Nauman (b.1941) and the conceptual interventions of Robert Smithson (1938–1973) and Gordon Matta-Clark (1943–1978), Orozco also encountered the work of British sculptors such as Tony Cragg (b.1949), whose precise sculptural employment of found objects and debris as well as his interest in the 'relationship of the part to a whole' and particle physics offered an intellectually grounded departure from the industrially fabricated art of the minimalists (indeed Orozco was familiar with the work of British sculptors of Cragg's generation from *Transformations*, a significant exhibition of British art, including Cragg, Antony Gormley (b.1950) and Bill Woodrow (b.1948), which took place in Mexico City in June 1984). Orozco has said that during this period he 'started to collect things in Spain that were mostly pieces of wood in the street or a bit of garbage. Sometimes I would bring them to my studio and do things with them but then throw them into the trash. So it was like having objects around but then they would always end up destroyed.'

Many of his interventions in the park or on the street remained undocumented and Orozco has spoken of the importance in the development of this activity and such chance encounters as the writing of John Cage (1912–1992), whose book he was reading in Madrid. Orozco has in addition cited the events of the Mexico City earthquake in 1985 as instrumental in his move to document the materials and situations he encountered on the street. The streets of his hometown had until that time been familiar to him largely through the experience of a car-based navigation of the urbanscape. After the earthquake Orozco explored the ruined city on foot and, with the help of cameras borrowed from friends focused more exclusively on this media, he took images of the destruction that he encountered and at the same time developed a sensibility for walking rather than driving through the city, a habit that he continued in Madrid during his time there and which has subsequently become a trope of his work.

On returning to Mexico in 1987, Orozco continued to work in this vein, becoming particularly interested in the outskirts of the city for the material opportunities it presented. Although he had made a handful of photographs of his interventions in the public realm in Madrid and in Mexico, just before his departure for Brazil with Gutierrez in 1991 he acquired a small Nikon autofocus camera that enabled him to document his encounters without being encumbered by bulky equipment. Photography, however, was not his ambition per se and he has stated 'I was always more interested in drawing or making objects.' In particular, he was not interested in replicating the type of romantically inclined documentary photographs that artists of his parents' generation were producing. Emphasising the importance of trying to create art that spoke for itself, Orozco has said:

COINS IN WINDOW 1994 [3]
Silver dye bleach print
40.6 x 50.8
Edition of 5

RIVER OF TRASH 1990 [4]
Silver dye bleach print
40.6 x 50.8
Edition of 5

RECAPTURED NATURE 1990 [5]
Vulcanised Rubber
Approx. 75 x 105 x 85
3 versions

Transparency is for me the main realisation in the work. The work is not trying to explain, it's not trying to convince, it's not trying to amuse, it's not trying to amaze, it's not trying to convert ... All those things a lot of art has tried to do, especially in Mexico, and I was trying to break with that.

The few photographs that remain from this period, among them *Stones in the Fence* 1989 and *River of Trash* 1990, indicate the direction in which Orozco's photography would continue to develop. *Stones in the Fence* (fig.2) documents an intervention with the landscape, in this case the creation of a line 'drawn' in stones that playfully manipulates spatial depth such that the horizon line of stones sits on the surface of the image, creating a disjunction between foreground and background (an effect Orozco continued to put to use in later images such as *Coins in Window* 1994 (fig.3) as well as in such incised photographic images as the *Atomists* series 1996 (figs.72–3), while simultaneously imposing another geometry on the otherwise apparently organic nature of a found situation – the grid of the gate, orderly garden border and walls already dictating a linear composition. *River of Trash*, (fig.4) meanwhile, is clearly a found situation documented on the spot but once again anticipates future work, revealing a tendency to create or identify all-over imagery that is replicated in images such as the photographic *Total Perception* 2002 (fig.6) or Orozco's more recent venture into geometric painting, and is suggestive of a cosmic canopy, a dispersion that implies some form of connectivity between the parts of the whole.

Although his works were rarely shown in Mexico in the late 1980s and early 1990s – an exception being in *A propósito* in 1989, the exhibition he co-curated with writer and curator Guillermo Santamarina (b.1963) and an homage of sorts to Joseph Beuys (1921–1986),

for which he made an installation – Orozco participated in other ways within the art scene, establishing an unofficial school in Mexico City with a group of younger artists that has arguably helped to change the landscape of contemporary art in Mexico over the last two decades. Artists Abraham Cruzvillegas (b.1968), Gabriel Kuri (b.1970), Damián Ortega (b.1967) and Dr Lakra (Jerónimo López Ramírez) (b.1972) would come to Orozco's studio for the regular Taller de los Viernes (Friday Workshop) at which no teaching as such took place but rather an exchange of ideas, reading and learning through observation, extending over five years.

Among the objects that Orozco made during this time in Mexico were *Recaptured Nature* 1990, a cut and patched inner tube of a tyre inflated into a sphere (fig.5), and *My Hands Are My Heart* 1991, an impression of the artist's hands on a small mound of fired brick clay (figs.7 and 8).

Of *Recaptured Nature* Orozco has said, 'I think that work's very important in the end, because it's the first time I used a sphere, but also the first time that I cut and disassembled an object. So it can be seen as a pre-cursor for *La* DS.' Indeed, *Recaptured Nature* contains many of the concerns that have characterised Orozco's oeuvre. Firstly, the material is one that has been recycled from everyday use, is readily available and has no direct association with 'art' materials as such. Secondly, as the title suggests, the material is not disconnected from its original use or purpose: the artist reinflates the rubber inner tube recalling its original function to facilitate movement or transportation, which the implicitly rolling and untethered rubber ball immediately brings to mind. Thirdly, as Orozco notes, the work entails the act of cutting and reassembling in altered form to exaggerate or increase the original function of the object –

TOTAL PERCEPTION 2002 [6]
Chromogenic colour print
40.6 x 50.8 Edition of 5
85.7 x 118.7 Edition of 3

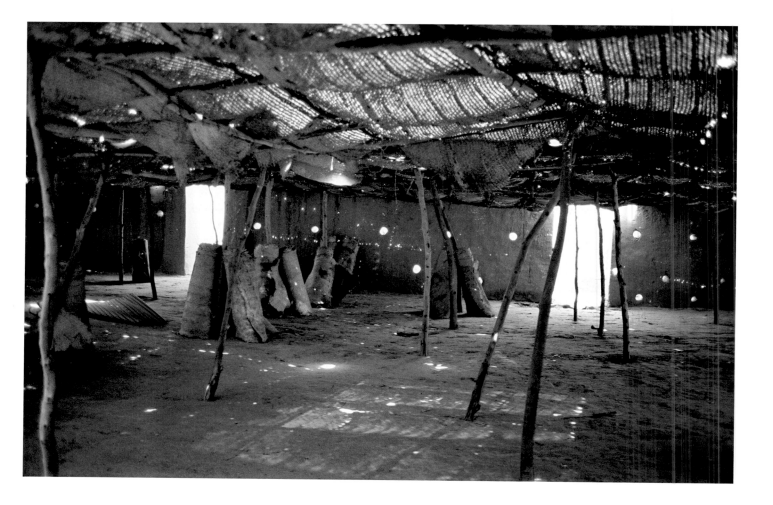

MY HANDS ARE MY HEART 1991 [7]
Fired clay
15.2 x 10.2 x 15.2

transportation here becomes unstoppable move-ment – and of course the themes of travel and migration are ones that recur throughout his work. Fourthly, the spherical shape itself and the manner in which it expands are at the heart of Orozco's thinking and his constant references to growth, origin and the notion that everything starts with a bubble. Orozco denies the relationship to Marcel Duchamp (1887–1968) suggested by the use of the wheel and the altered found object, about which he has said, 'I wasn't thinking of Duchamp so much. I think it had to do with the object itself. I started to be more and more interested with the idea that the object lends itself to something else. In this case it's an inner tyre that is inflated, and how to extend that potential.'

But as with many other works by Orozco, *Recaptured Nature* contains within it a rich history of art historical precedent: from the inflated and deflated balloons of Piero Manzoni's (1933–1963) *Fiato d'Artista* 1960 (Artist's Breath) to the circular cutting of a Matta-Clark intervention, who alongside Smithson is also important for bringing the street into the gallery or museum setting – an aspect that is a feature of *Recaptured Nature* and continues to define Orozco's practice.

Recaptured Nature was shown alongside *My Hands Are My Heart* in Orozco's first representation in a major international exhibition, *America, Bride of the Sun*, co-curated by Catherine de Zegher for the Royal Museum of Fine Arts, Antwerp in 1992. This was one of the many exhibitions around the 500-year anniversary of the discovery of the Americas but was distinguished by its thematic and analytical view on the role of imperialism as well as the remarkable inclusion, for its time, of artists such as Cildo Meireles (b.1948) and Lygia Clark (1920–1988).

In appearance, *My Hands Are My Heart* can easily be associated with the type of surrealistic and romantic imagery derived from Mexican artists such as Frida Kahlo (1907–1954). Discussing the origins of the piece, which was made while he was helping Gormley to establish the large enterprise that was necessary to produce *American Field* in 1990, Orozco argues for a more intuitive emergence of the work than this inheritance implies. Recalling this time, Orozco has said:

I found this place in Cholula, which is a town that just makes bricks. It's an amazing place. So we spent two weeks doing the production of the work. And I remember at some point, I took up a piece of clay and I just did it as a gesture, I didn't plan it. And then I put it in the oven with all the other pieces, and then it came out, and it was perfectly cooked. It looked really great. Antony looked at it and said, 'Hmm. Maybe in that you have everything I'm trying to say in the whole production of these thousands of pieces – maybe in that one piece you have said everything.'

The timing of *My Hands Are My Heart*, its imme-diacy in making as well as the manner in which the brevity of the gesture is so evidently captured, sets it apart from the romantic and literary use of the heart as a laboured motif in the work of Mexican artists such as Kahlo. However, with this piece and others Orozco seems to intentionally occupy the territory of a nationally identified form or cliché in order to ques-tion such concepts. Theorist and friend of the artist, Benjamin H.D. Buchloh, has examined this tendency with regard to Orozco's oeuvre and in particular to *Black Kites* 1997 (fig.37), a human skull overlaid with a geometric graphite grid. Buchloh reached the following conclusion: 'the specificity of the local, regional and national iconography operates as a mnemonic register in Orozco's work to articulate the

MY HANDS ARE MY HEART 1991 [8]
Two silver dye bleach prints
Each print: 23.2 x 31.8
Edition of 5

complex process of subject formation as one of inevitably originating, yet necessarily being emancipated from, all forms of mythical subjection.'³

Apart from the perhaps surprising use of the heart motif in *My Hands Are My Heart*, the small sculpture further stands out among Orozco's oeuvre for the photographic diptych (fig.8) of the piece that incorporates the artist's own torso and his hands holding and then exposing the object. Orozco has always remained the absent performer in his photographic interventions, his presence being implied but never physically demonstrated. When asked how this unusual image came about, he replied:

It was kind of an accident. A friend of a friend was doing a documentary about new art in Mexico and wanted to film me. When he saw this piece he wanted a shot with my hands on it. I said, 'Well, let's do it differently,' and I lent him my camera and told him how to shoot it. So then I took off my shirt and I did the gesture, he took the two photos, just two photos, they were the last two photos of the film.

Once again it seems that the origin of the act, here a photographic one, was close to accidental. Far from the posed and carefully conceived symbolic performance we might imagine, the two images are the result of coincidence, as tenuous as the making of the object itself. When pressed, as he has frequently been by Buchloh, as to the critical and artistic inheritance evidenced in his actions and in particular the potentially reactionary appearance of some of his gestures (that witness a return to hand craft, narrative and most recently painting), Orozco in general deftly avoids placing his work in such a contextual lineage emphasising instead the aspects of exploration and simple (but not naive) experimentation as the driving forces behind an action. His impetus, he says, is not to continue or break with artistic tradition but rather to

negotiate with the real. In conversation with Buchloh he has said:

*The most important step for an artist, at least for me, is to re-establish, or at least to develop contacts, or bridges, in our relationship with reality – the real, whatever it is. That thing that is outside of us, that thing we need to know, that we want to explore in order to understand the world, ourselves and the time we are living in.*⁴

Orozco's titles may seem to belie the realist tendency that he wishes to explore and there is no denying the alliterative and poetical qualities of *My Hands Are My Heart*. However, the artist accepts this associative aspect in his work stating:

In the titles I touch on some kind of narrative. I am not a minimal artist. I don't believe the object in itself is what it is. I think there is always language around an object, but the title that I am putting on the object is a real language. And that transparency is for me the final realisation of the work, when I feel it's transparent enough, I don't have to give any more explanations.

The title of *Dial Tone* 1992 (fig.9) is similarly suggestive, though here incorporating a Cage-like sound element into an otherwise silent sculpture. Returning to the action of cutting and reconfiguring explored in *Recaptured Nature*, Orozco made *Dial Tone* from the pages of the Monterrey (Mexico) phone book, which were cut to remove the names and the resulting rows of numbers then pasted onto a ten-metre (34 ft) long Japanese scroll. Orozco has said that the idea for the piece in fact emerged from his experience of moving to New York with Gutierrez in 1992. He recalls:

Every time I arrived in New York the first thing I saw in an empty apartment was a phone book. So it was the first object you got when you were there. And of course all the inhabitants of New York are in there, all the names,

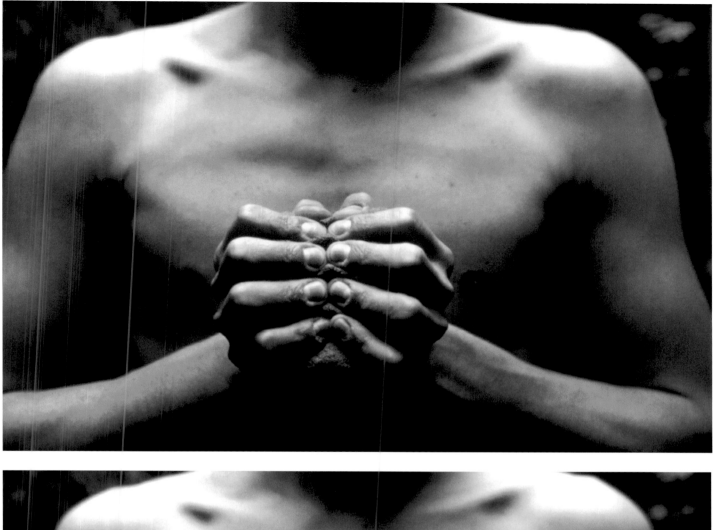

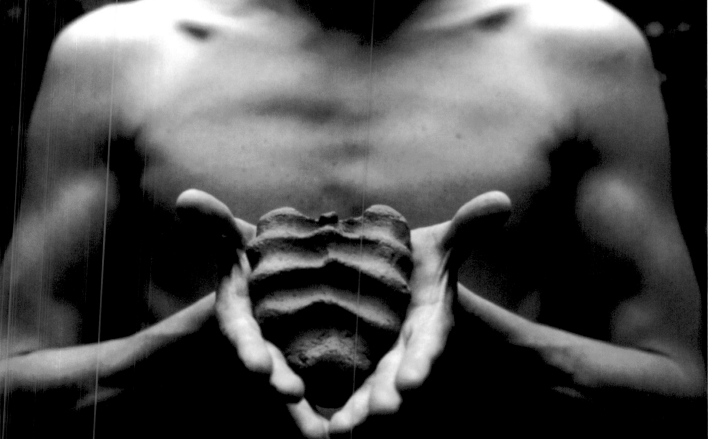

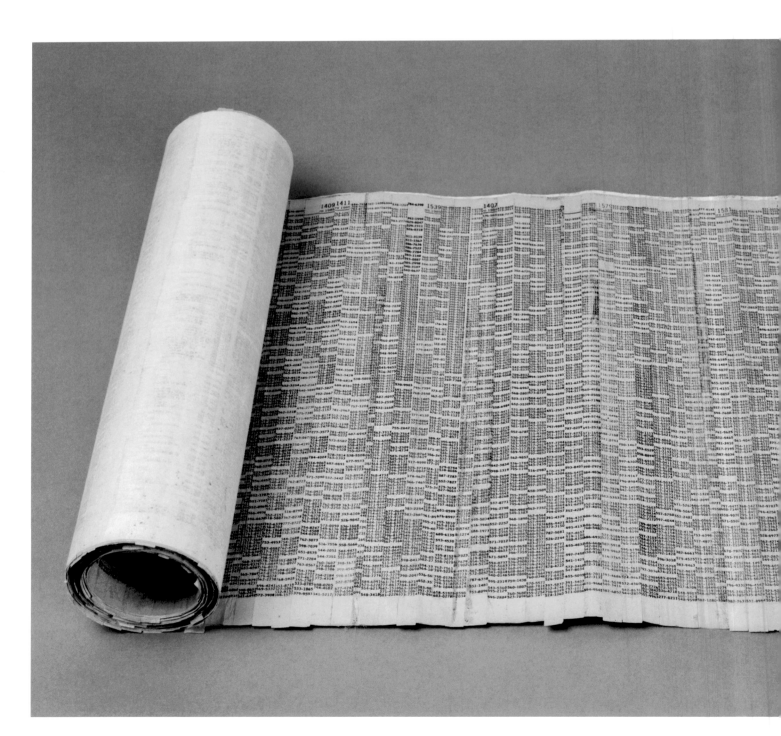

DIAL TONE 1992 [9]
Cut-and-pasted phone book
pages on Japanese paper
27.9 x 1,036
3 versions

but you don't know anybody, I didn't know anybody. So I decided to play with it – I think it looks like a musical score ...

Dial Tone was shown alongside *Yielding Stone* 1992 (fig.10) in an exhibition at the Museo de Monterrey, a piece that he was to repeat in New York for the New Museum of Contemporary Art the following year.

YIELDING STONE 1992

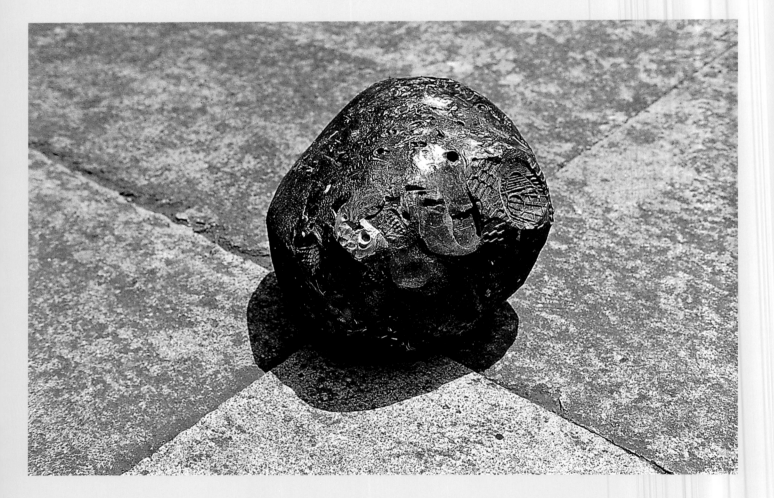

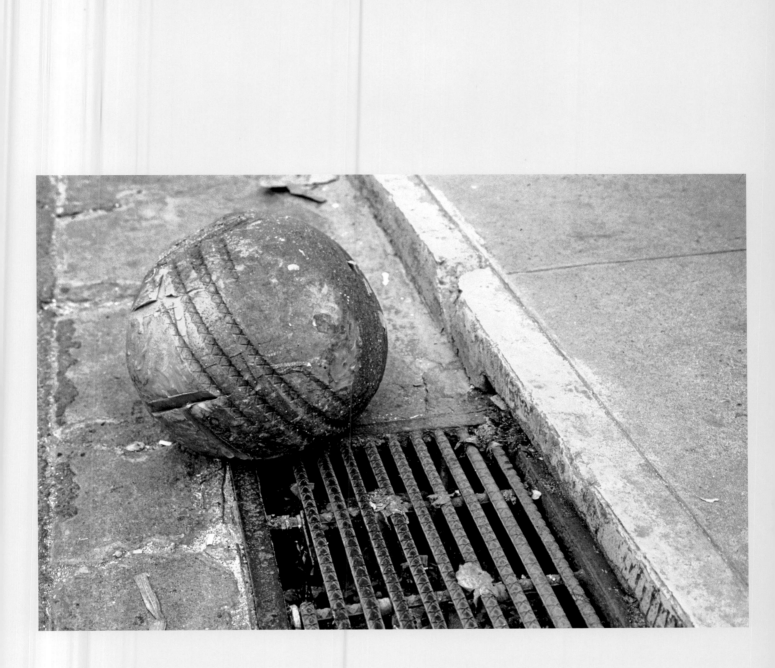

YIELDING STONE 1992 [10]
Plasticine
Approx. 35.6 x 43.2 x 43.2

First made for an exhibition in Monterrey, *Yielding Stone* consists of what was then the artist's weight in plasticine, hammered into a rough sphere and then rolled through the streets adjacent to the museum. Like *Recaptured Nature* 1990 (fig.5), it is an imperfect sphere, lopsided and uneven and, due to its material substance, pitted and dirtied, its surface containing the memory of its movements and the audiences' curiosity. While *Recaptured Nature* was only suggestive of movement, *Yielding Stone* is the result of its travel – its form impossible to achieve without the action of rolling. It transports both the memory of the public space and quite literally its materiality when brought into the gallery: an atypically 'unclean' infringement on the museum's aspiration for the sanctity and control of a dust-free environment. The action of rolling the ball through the street recalls Michelangelo Pistoletto's (b.1933) *Palla di giornali (Oggetti in meno)* (*Ball of newspapers (Minus objects)*) 1966, which, as curator Francesco Bonami (b.1955) has observed, was 'employed within a social context before becoming a sculpture' having been pushed through the streets of Turin before being enclosed in a metal cage and exhibited, retitled, as *Mappamondo*.[5] Unlike Pistoletto, though, Orozco's action of rolling *Yielding Stone* through the streets remained a one-off private act. Pistoletto's work had a public performative aspect (as documented in the photographs that show him and others rolling the paper ball) and has even been repeated for public events at a later date. Orozco remade *Yielding Stone* for the exhibition *In Transit* at the New Museum of Contemporary Art, then located on Broadway, though it had in fact been the invitation to participate in this show that had inspired the piece in the first instance.

JESSICA MORGAN Plasticine is a material identified more often with children's play than sculpture. What led you to use this material for *Yielding Stone*?

GABRIEL OROZCO I was here [in New York] and Jimmie Durham (b.1940) had a show at that time, and when he finished he had some material left over, so he called me and told me, 'Look, I have all this material I'm not going to use, and I'm leaving. Come and have a look.' And there was some paper and other things and plasticine. I took it to my apartment. I was planning to do a book at that point, and I wanted to make a book as an object, and I started to model it in plasticine. But then the plasticine became one thing and then another thing and then another thing, and I took it outside and I took pictures of it in the street, and then I decided to roll it.

JM You mean it grew gradually, the ball?

GO No, I would say that at first I did some objects on my table with a small amount of plasticine, and I liked them a lot: it was obvious that the potential was there to look really amazing. Then I was invited to Monterrey for an exhibition and also to participate in the New Museum of Contemporary Art exhibition *In Transit*, and my project was to do it big. So it's not that I did it big and then I had it in my apartment, waiting for a show.

JM And the act of rolling it through the street, what was your intention?

GO Basically, the action is what makes the work. The shape, the final realisation of the sculpture, is through this action. It's not first the sculpture and

then the action. The making of the piece *is* the movement. Because at the end, when you hammer it and put it together, you have to roll it to really shape the object, to really try and consolidate the whole thing. It's like when you are preparing bread or something, to consolidate anything you roll it and press it. So it's a basic gesture. And because the plasticine is a greasy material, there's no hardening, it always changes and also all the dust accumulates naturally into the plasticine.

I also think that's important in my work, that when you see the object, you can see the process of its making, that it's very evident. And that's why I like to use the word 'phenomenology' in relation to my work, because I think that the concept of the making of the work is always represented in the final product, without me having to explain it. When you see *My Hands Are My Heart* or *Recaptured Nature* or *Yielding Stone*, you can immediately understand how they were made, and that the making made the pieces. There is not any literature attached to the objects.

JM The gathering of dust or dirt by the work seems very important.

GO I think that I started to connect, and I still connect, the idea of brightness or cleanness with the idea of movement and it is the opposite of dust. Dust is when things are not moving, they are static; dust makes everything opaque. What I like with plasticine is that it feels organic. Because the oil and greasiness with the dirt and malleability make it feel alive somehow, it feels like skin in a way. But when you add the dust on top of the greasiness, the grease absorbs the dust all the time. It's such a basic material that you can immediately feel the malleability of space and time in terms of how you use it and how it's just changing all the time.

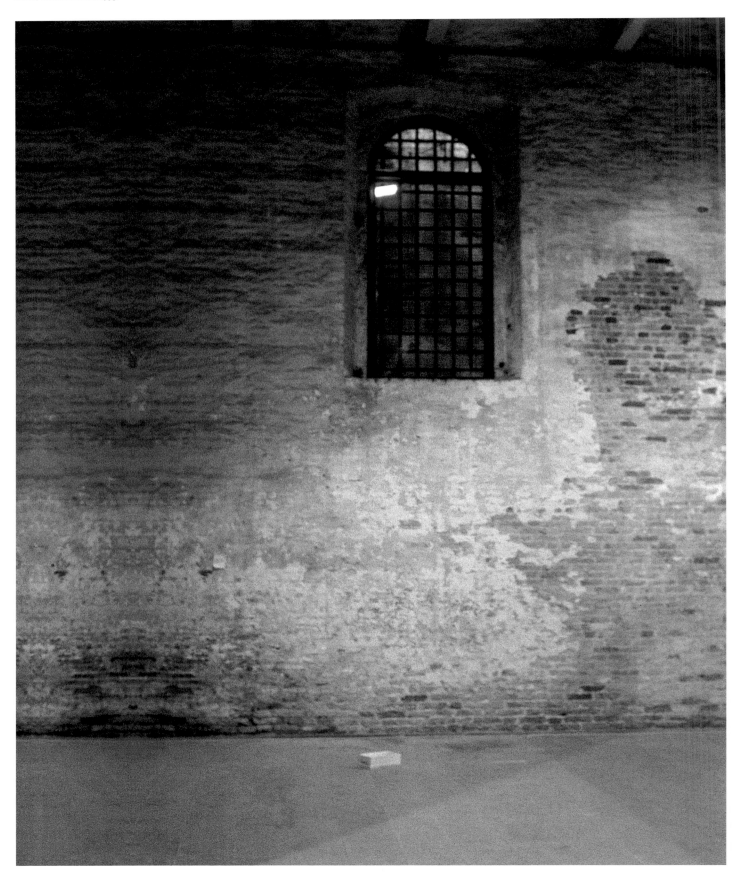

EMPTY SHOE BOX 1993 [11]
Shoebox
12.4 x 33 x 21.6
Installation view of 45th International
Art Exhibition: The Cardinal Points
of Art, Venice Biennale, 1993

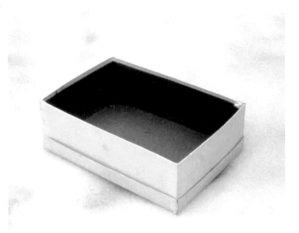

EMPTY SHOE BOX 1993 [12]
Shoebox
21.4 x 33 x 21.6

'SCULPTURE AS A FRUIT'

2

By 1992, Orozco was travelling extensively, but predominantly living in New York and visiting Mexico regularly. The excess of 1980s painterly production was on the decline, and a new generation of artists and curators was beginning to emerge who were moving away from the potentially reactionary return to painting and the dominance of a gallery star system. Europe led curatorially in innovative practice: *Magiciens de la Terre* at the Centre Georges Pompidou, Paris in 1989 was the first exhibition that decentred art from the West. The exhibitions of Hans Ulrich Obrist (b.1968) for the *Migrateurs* programme at the Musée d'Art moderne de la Ville de Paris (from 1993) featured many of the artists who became the central figures of the decade, among them Douglas Gordon (b.1966), Rirkrit Tiravanija (b.1961), Pierre Huyghe (b.1962) and Orozco. Exhibitions such as Nicolas Bourriaud (b.1965) and Jerôme Sans's (b.1960) *Traffic* in 1996 at CAPC Bordeaux similarly brought together like-minded sensibilities whose working practice was characterised by the ease with which they moved from place to place: they no longer felt tied to the 'centres' of artistic production that had dominated the last decades, their work evincing portability and often ephemeral temporality. Although artists' travel was in itself not a new thing, the extent and breadth of this activity reached new heights with the flourishing of art institutions and the increasing interest in global biennials and major international exhibitions.

Key among Orozco's artist colleagues from this time was Tiravanija, whose first open cooking event, *Untitled 1992 (Free)*, took place that year at 303 Gallery in New York. Tiravanija and Orozco occupied a similar position within the group exhibitions that took place during the first few years of the 1990s, their work seen as indicative of the current interest in migration, movement and an investigation of the 'real', and their

shared emergence from non-western locations offering an alternative perspective. Their work was included together, for example, in the exhibitions *Real Time* at the Institute of Contemporary Art, London (1993), *Beyond the Borders*, the Kwangju Biennial (1995) and *Traffic*, and although both artists resisted the notion of being tied to their national identity (an identity that in Tiravanija's case was already multiply displaced), there was undoubtedly a degree to which they fulfilled the increasing demand at the time to represent the position of Other.

Speaking about the importance of their friendship at this time but also their difference as artists, Orozco has said:

Rirkrit came to the US before me and he studied here, so in that way he was more 'American' than me. In the 90s he became my best friend here in New York. We started to show together in different ways, and to be associated, but I always thought that my work was very different to his. I admired the process and the placement of the situation in his work, and I enjoyed immensely all the phenomena around the situation of his cooking and the gallery openings and the people. The best part of his work is the situation and the performance, but I am not like that. My performances or my actions are more intimate, on the side.

Through the art that he produced and the exhibitions in which he took part at this time, we are aware of Orozco's keen understanding of the way the art world operated and in particular the capacity to categorise and label artists according to nationality, type and the needs of the market and publicity. While his work was not made in response to this potential limitation, the deliberately underwhelming nature of many of his projects indicated a refusal to perform for the genuine interest that was beginning to develop around him. Orozco most notoriously avoided the

MELON 1993 [13]
Silver dye bleach print
40.6 x 50.8
Edition of 5

position of spectacle when he exhibited *Empty Shoe Box* 1993 (fig.12) as part of his contribution to the Aperto section of the 1993 Venice Biennale curated by Francesco Bonami. The sculpture consisted precisely, as its title implies, of a shoebox with its lid removed and put underneath it, the empty box placed directly on the floor. Orozco insists that he was not looking to incite a reaction, instead he says, 'it was very subtle, many people didn't even look at it, other people had some complaints about it but it was not a violent gesture or a kind of provocative gesture, not an avant-garde gesture. An avant-garde gesture is a more violent provocation, or a kind of claiming of something, and I don't think my work is like that.'

Instead, the inspiration for the piece came largely from his habit of keeping objects and drawings that he is making or working on in shoeboxes in his apartment. Orozco has said:

At some point, when I was thinking and taking things out of the shoeboxes, I realised that the shoebox on the floor like that, empty, was something I liked. For Venice, which was my first big international show with many of my peers, the spaces in the Aperto were small and one after the other. I found it really impersonal and very tough to show work in an environment like that. I decided to show the shoebox, like a space inside the space, a very common but at the same time abstract object. So the whole thing is doubled. It's not an object you could find in an art sale or in an art biennial, but at the same time it is not impossible that you would see something like that. It is common but it's not so common.

The empty shoebox placed on the ground, its lid performing the role of a pedestal, acted as a replication of the space in which it was presented, as its dimensions mimicked the rectangular proportions of the bay. Despite the work's proximity to the 'disinterest' defined by Duchamp as essential for the

readymade, Orozco is adamant that it is not a readymade. He says, 'I was not thinking, "This is a readymade". The shoebox was on the floor, it was not glued to the floor, it was kicked about – it was a shoebox, not a readymade. It related to the emptiness of space, which I don't think is true of readymades.'

Orozco has frequently referred to this notion of the empty space as a recipient in relation to his work. It is a phrase with multiple implications for the artist and about which he has said, 'everything about my work has to do with transportation, I think, at the end. The vehicle is important, or the recipient. The *Empty Shoe Box* is a recipient, the *Yielding Stone* is a recipient. Something that is a container or even oneself as a recipient.' It is a notion that, particularly with *Empty Shoe Box*, brings us back to the significance for Orozco of maintaining the position of migrant. The portability and practicality of moving and displaying the piece, as well as its purpose as a container, literally relate to the reality of mobility. *Empty Shoe Box* also demonstrates the difference in Orozco's use of 'poor materials' to that of Arte Povera. While the latter elevated the organic and the everyday to a form of monumentality (using the contrast between the placement of the everyday material within the art environment to produce this friction and alteration), Orozco uses the banal neither to alter the space in which it is presented nor to enhance the material itself to a higher status. *Empty Shoe Box*, unlike the 'disinterest' invoked by the Duchampian readymade, is the recipient of 'interested' human attention; it represents the Other when placed in the exhibition context.

Like many artists of his generation who questioned the separation of curatorial and artistic practice, Orozco is strongly identified with a particular approach to exhibition making. His installations of his own work, much like the visual reference within

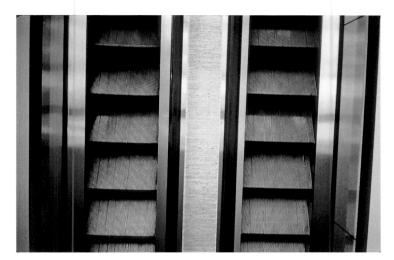

DIAL TONE 1992 [14]
Cut-and-pasted phone book pages
on Japanese paper
27.9 x 1,036
Installation view of *Projects 41:
Gabriel Orozco*, The Museum of
Modern Art, New York, 1993

Empty Shoe Box to its surrounding location, intimately connect to the space they occupy and at their most successful respond both to the physical, architectural nature of the location and to its contextual history and relationship to an ever-expanding network of social and economic connections. This can be as simple as the placement of *Empty Shoe Box*, which after all took place in the best-known Italian exhibition, suggesting a conscious connection to the Arte Povera artists, whose process and sculpture Orozco is undoubtedly indebted to, rather than to Duchamp – especially as the accompanying piece that he presented was a larger version of *Yielding Stone*, titled *840lbs Net Black Plasticine* 1993, which, due to its comparable scale, drew an even closer analogy with Pistoletto's work.

However, it is in his more expansive exhibitions that Orozco is able to articulate his treatment of space and time. The first opportunity he was given to explore this type of solo presentation took place immediately prior to the 1993 Venice Biennale at the invitation of Catherine de Zegher in an exhibition presented by the Kanaal Art Foundation in Kortrijk, Belgium. Here Orozco showed a number of new and extant works but in particular he was able to build on the internal development of the exhibition. He has said of the exhibition that it was 'an experience of time that went from floor to floor in the building. I think that is my favourite way to work, you build up time inside the show.' Incorporating the dust that he swept up from the floor of the abandoned brewery where the show took place, as well as situating other works that suggested the artist's physical presence in the space, such as the negative void of his hand as outlined in *My Hand is the Memory of Space* 1991 (fig.15), Orozco built up an experience generated by his interventions that could not be summarised in one piece. Orozco had

similarly taken care to use the installation of his works at the ICA, London, in the exhibition *Real Time* curated by Gavin Brown in 1993, to direct the meaning or the encounter with the individual piece. Here Orozco made such understated gestures as placing *Yielding Stone* in the lobby and positioning a melon on the shelves of the ICA's bookshop (fig.13) – an act that seemed to mimic his photographically documented actions. The melon, itself a highly sculptural fruit, in combination with the placement of Orozco's other works in non-traditional spaces of the gallery, recalls Buchloh's observation that the artist has the unique ability to make sculpture appear as 'a naturally occurring phenomenon'.[6]

Orozco's interest in occupying 'non-art' spaces in the gallery clearly informed his *Projects 41* exhibition at the Museum of Modern Art, New York in September 1993. The *Projects* series, which showcases younger or emerging artists, in general takes place in a fairly conventional manner in a space allocated to it. Orozco, however, was not interested in using the designated gallery and instead wanted to interact with the workings of the building. Rather, he was concerned with the action within MoMA, which he describes as (at that time) 'quite a corporate building, with a lot of corridors and people moving around, a quite tight space, and active.' Orozco's solution was to place sculpture in interstitial places. While *Empty Shoe Box* disappeared by nature of its commonality, here Orozco's works merged with the transitional spaces of the museum and due to their unassuming position they functioned more as insertions into the system, subtle infringements on the normal dictates of the institution. Among the works displayed was *Dial Tone* (fig.14) – which was placed running down the slope between the up and down escalators – a stream of numbers that visitors similarly flowed by. In the

MY HAND IS THE MEMORY
OF SPACE 1991 [15]
Wooden icecream spoons
Dimensions variable

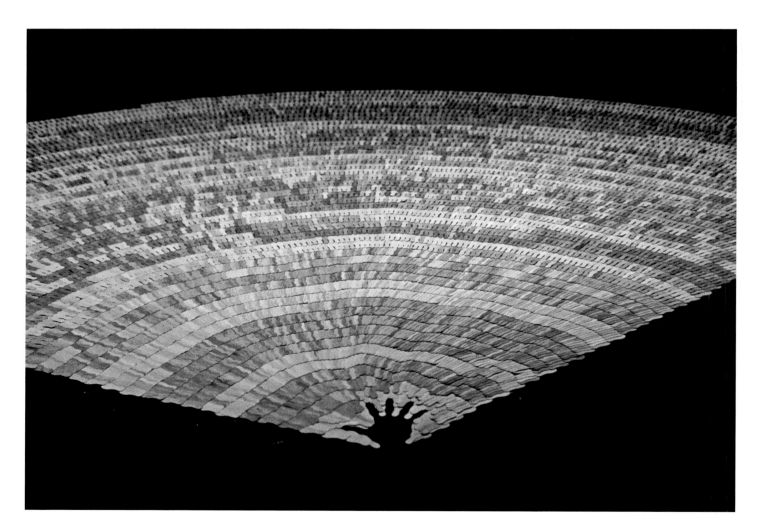

HAMMOCK HANGING BETWEEN
TWO SKYSCRAPERS 1993 [16]
Cotton hammock
Dimensions variable
Installation view of *Projects 41:
Gabriel Orozco,* The Museum
of Modern Art, New York, 1993

sculpture garden, Orozco installed *Hammock Hanging Between Two Skyscrapers* 1993 (fig.16), a work that interrupted the formality of the garden (which was largely occupied by figurative sculptures), offering on the one hand an alternative platform for the placement of another physical presence, the viewer, while on the other formally suggesting a cutting or slicing of space through the curved line of the hammock.

Completing the visual ping-pong that Orozco established within and without the museum was *Home Run* 1993 (figs.17–18), for which the artist asked the museum curator, Lynn Zelevansky, to negotiate with the occupants of the apartments across the street from the museum to place oranges in their windows. Orozco has described how this work was a fairly last-minute addition:

Two weeks before the opening the idea of the oranges came up. I was interested in the idea of private/public space and the idea of public sculpture, especially in MoMA. It was a discussion at the time and I was taking part in it. How to make a public/private sculpture that happens in the civic area, in the street, and how to bring its reality into the museum or gallery. This is an important part of the way I like to think. How you bring reality into the realm of the institution.

It is interesting to think about Orozco's intention with *Home Run* in relation to the work of Los Angeles-based artist Michael Asher (b.1943) and the practice that has come to be termed Institutional Critique. Generally defined as a commentary on the various institutions and assumed normalities of art, Institutional Critique seeks to make visible the historically and socially constructed boundaries between inside and outside, public and private. In addition, Institutional Critique often draws attention to how distinctions of taste are not separate from aesthetic judgement, and makes apparent that taste is

HOME RUN 1993 [17]
Oranges
Dimensions variable
Installation view of *Projects 41:*
Gabriel Orozco, The Museum
of Modern Art, New York, 1993

HOME RUN 1993 [18]
Oranges
Dimensions variable
Installation view of *Projects 41:*
Gabriel Orozco, The Museum
of Modern Art, New York, 1993

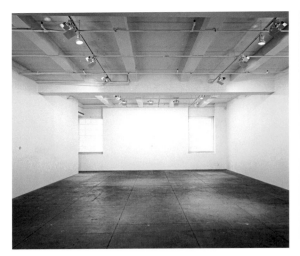

YOGURT CAPS 1994 [19]
Four yogurt lids
Each 7.9 diameter
Installation view, Marian Goodman
Gallery, New York, 1994

YOGURT CAPS 1994 (detail) [20]
Four yogurt lids
Each 7.9 diameter

an institutionally cultivated sensibility. Orozco's work suggests an interest in exposing the limits of the institution, by muddying the distinctions between inside and outside and drawing attention to the conservative delineations of what constitutes sculpture and where and how art can be shown in order to be considered art.

However, Orozco's critique, if we can call it that, and real interest seem more in dialogue with a perceptual and phenomenological process of seeing and experiencing in relation to the human body and the corresponding body of sculpture (or real objects). Other installations of Orozco's from this time could be interpreted as pointing to a critical assessment of the institution or the artwork but, apart from the fairly consistent writing of Buchloh, in which he argues that Orozco's oeuvre firmly positions itself as politically charged, other interpretations of the artist's output have varied widely. After his exhibition at MoMA, Orozco had his first one-person show at Marian Goodman Gallery and made the decision to show in the initial gallery – the large space that is entered on arriving by lift – nothing but four yogurt pot lids, one on each of the walls. *Yogurt Caps* 1994 (figs.19–20) has elicited the most wide-ranging of interpretations, summarised by art historian Miwon Kwon as a gesture 'received by some as deeply disappointing and by others as extremely courageous – a glib and cynical manoeuvre or a brilliant critique of the gallery system'.[7] Orozco has suggested that the installation had great sculptural and formal relevance, going so far as to say '*Yogurt Caps* was my research of space, spectatorship, the viewer, the poetic, the emptiness, the body in movement, the white box as container, the container in general, the circle ... Everything was in that work.'[8] But, interestingly, within this statement he does not claim criticality as among the key concerns.

The project that perhaps most suggests a critique of the institution of art, or at least its commercial aspect, is *Parking Lot* (figs.21–2), the installation that Orozco undertook at Galerie Micheline Szwajcer in Antwerp in 1995. Located in a busy area of the city that suffered from a lack of parking places, Orozco decided to open the street level gallery such that the space was transformed for the duration of the exhibition into a car park. This alteration of purpose could be read as a gesture making apparent the commercial basis of the space, stripping away the aesthetic veneer and exposing the gallery as an enterprise no different from any other whose sole purpose is to exchange products for money. Differing readings are perhaps more in line with Orozco's consistent concerns, however, and once again we can interpret the work as one concerned with space as a container or receptacle, the flux of materiality entering and departing relating it to a wider network of connectivity and blurring the boundaries between inside and outside, public and private. Also, as curator and writer Guy Brett has observed, Orozco's work could be seen as a commentary on the history of the void in contemporary art:

Encapsulated in the idea that an anonymous passerby, in the act of blithely solving a banal problem of everyday urban life, could unconsciously contribute to the elucidation of a crisis in the direction of contemporary art, a choice of alternatives that can lead the way to a pointless, self-referential trap or open up to the possibilities for a vitality of art-life interrelationship that is yet to come.[9]

But Orozco, when asked about *Parking Lot*'s origins and conceptualisation, has said matter-of-factly:

I never wanted to make something that was critical just for the sake of being critical. It is not my way of working. I related with the everyday reality. So for me the big deal

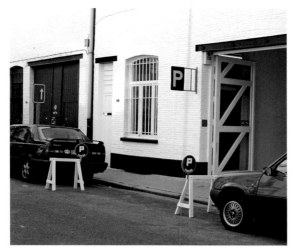

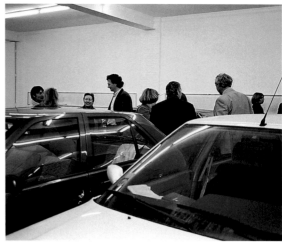

PARKING LOT 1995 [21]
Installation view, Galerie Micheline
Szwajcer, Antwerp, 1995

PARKING LOT 1995 [22]
Installation view, Galerie Micheline
Szwajcer, Antwerp, 1995

was how to bring real experience from everyday life into the realm of the white space, the platonic museum, or the exhibition. How to put the two together. So Parking Lot in fact came about because the gallerist, Micheline Szwajcer, was always parking on double lines in front of the gallery door all the time I was there. She had this big Mercedes-Benz station wagon double-lined with the flashing lights on in the car-packed small street ... and I was embarrassed. I guessed the gallery used to be a garage and with the two big doors opened you could drive in a car from the street. So I asked to turn it into a parking garage for the duration of my show. To suggest that for a month she became a good neighbour, giving a service to the people and no longer parking on double lines ...

In addition to the installations and larger exhibitions of multiple works, Orozco continued to produce individual pieces that contained within them layered concepts and references condensed into a single form. Many of Orozco's best-known sculptures from this time were altered industrial or commercial products, often vehicles, among them the sliced and narrowed Citroën DS, *La DS* 1993 (fig.25); *Four Bicycles* 1994 (fig.23), a sculpture for which the artist conjoined the bicycles to create one multi-wheeled structure; and *Elevator* 1994 (fig.24), an extracted lift that was cut and reduced in height to the size of the artist. Orozco has spoken of his concept for these and other sculptural objects saying:

I like to think of sculpture as a fruit. For me, sculpture is not something that is hollow inside. Like a fruit, what it is inside is related to what it is outside. The fruit is a vehicle, it's an important vehicle for the survival of the plant. The colour is the attraction, the structure of the fruit is how I like to think about all my sculpture: the idea of the centre of seeds, the flesh growing, flowing, the bubble, and then at the end you have the skin. La DS can be looked at like a fruit.

Elevator gave the impression of having turned this familiar space inside out. The exterior, not normally visible, was exposed as the skin of the piece, and what normally would be the surface, the interior space, took on the appearance of a hollowed out void. The slicing and reduction in scale of *Elevator*, following on from Orozco's alteration and acceleration of *La DS* through the cutting and narrowing of the car to enhance the impression of speed, recalled the memory of the movement of the lift and the sensation of rising in space to meet the top of the lift cabin. When it was first shown, viewers were able to enter the lift and experience this disconcerting effect.

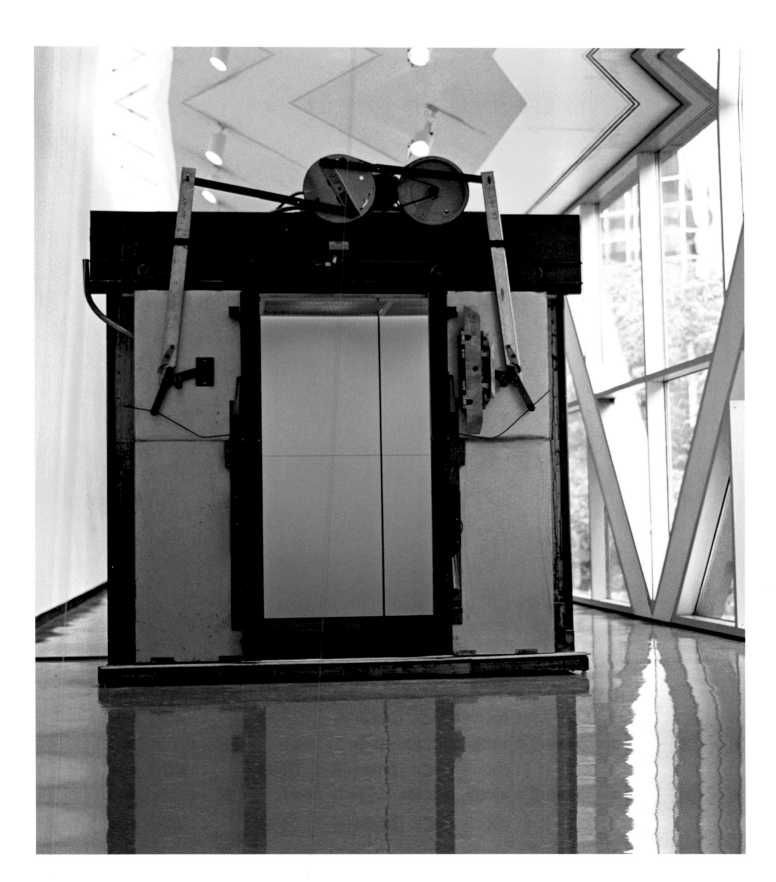

Perhaps the most iconic work made by Orozco, *La DS* was inspired by the classic car that was designed and manufactured in France in the 1950s and quickly became a symbol of post-Second World War economic recovery, a nationally embraced design that featured in lifestyle magazines, cinema and the popular imagination. Orozco's intervention was to carefully, with the assistance of his frequent collaborator Philippe Picoli, slice the car into thirds, remove the central portion and then fix the remaining two-thirds back together creating an aerodynamic abbreviation of the original car.

JESSICA MORGAN What made you think of slicing the car, and why the DS?

GABRIEL OROZCO When I was a kid I was obsessed with Formula One racing cars. I wanted to be a race car driver. I used to look at the cars on the street and imagine if you could cut them in half and reassemble them in a thinner line as racing cars, they would look great.

La DS of course sounds like 'goddess' in French. It's a kind of mythological name, and in France this car is a cultural icon. Of course I chose the car consciously. It is a car that has much meaning and a weight in terms of culture and history. There are many aspects – spatial, temporal, cultural, political, engineering – that make this gesture in this particular vehicle very attractive. It was also part of my childhood. When I do something with existing objects or any material, it's for me to understand what they mean, it's not that I know what it means beforehand. So I did it partly out of wanting to find out what it could mean to do something like that.

JM There seems to be a direct relationship to the human body with this work. When it was first shown, for example, you could actually sit inside the car.

GO A lot of my work tries to deal with the body in a very multi-angled way. The fact that my body does not appear in most of my work doesn't mean that it's not about the body. On the contrary, it's very much about the body, and the instruments that the body uses.

The act of cutting the car was a way to exaggerate the potential of the car, which I do in general when I reconstruct any object: to try to accelerate and expose exponentially the qualities of that object and that material. So from the moment I cut the car, the aerodynamics became more evident. Originally, when people could climb inside and sit in it, you could feel a little bit the speed, because of the compression, you could feel almost like you were moving. And that's a funny feeling, especially if you have some sort of memory of the car. Because in a way I'm cutting and reassembling the memory of the car. I am playing with the stereotypical memory of the identity of the object. It's the same with *Elevator*. How you remember the fact of being in an elevator, that memory is important to understand my work.

JM Do you see any difference between the works that you have made from altered commercial or industrial products and those made from natural materials?

GO I don't see any difference. Because there is not such a thing as a material without history or a 'natural material'. It just doesn't exist. Every material has a history in its production and its perception. And in a way, everything is already a product. Even if you have a piece of stone in front of you, somebody cut it out, somebody transported it. There is labour and investment implicit in every material you use. And I try to deal with this in the sense that, whether it's pigment, gold, a car, a tree or plasticine, the history of the material is always there. I'm not denying that history, I'm not erasing its history. I think that there is an awareness of the history of every material evident in the final look of my work. Pure matter doesn't exist any more at all. So when I use clay or cardboard or glass or porcelain I'm connecting with the history of the material, and also to the functionality of the material.

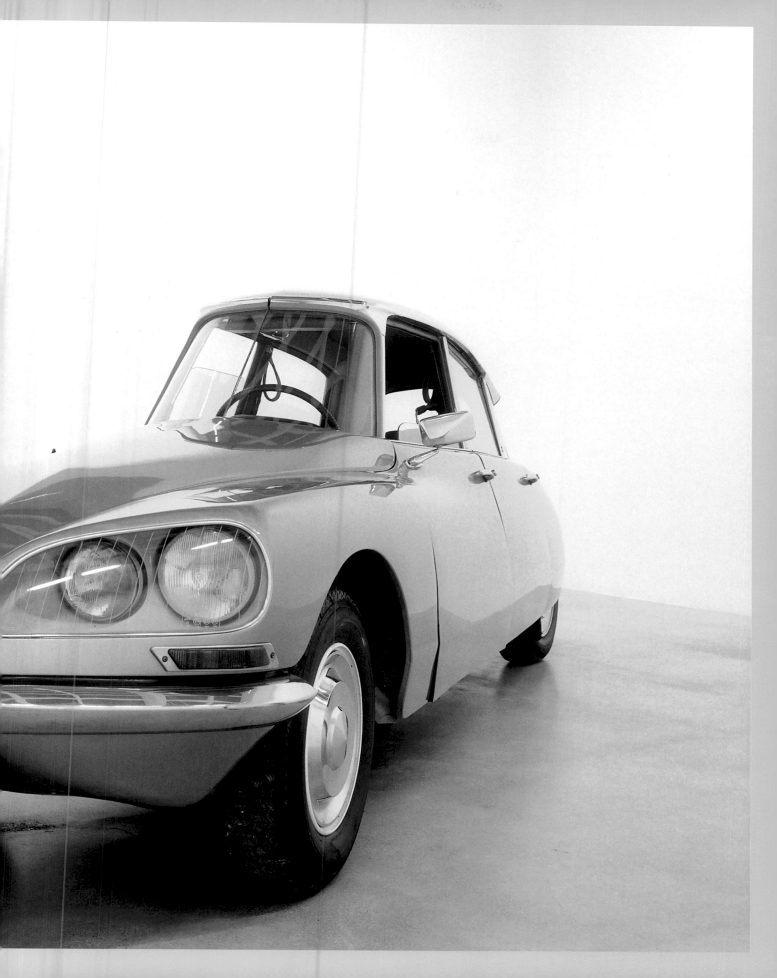

3

While Orozco's exhibitions at MoMA and Marian Goodman Gallery established him, from the perspective of the art community, as a New York artist, Orozco himself resisted the identification with a single location, and his work and movements reflect his continued interest in retaining a sense of dislocation from any one country or art centre. Exhibitions and residencies took him for periods of time in the mid-1990s to Berlin, London and Paris, the latter two cities hosting major exhibitions of lasting importance for his production in their exploration of site and the layered way in which Orozco brought together multiple inter-related pieces in the given space. Orozco's DAAD residency in Berlin offered him an opportunity to explore a city in a heightened state of transition after the end of the partition of East and West five years previously. He was able to be a tourist of sorts, navigating the terrain on his Schwalbe moped, an experience that resulted in the photographic installation *Until You Find Another Yellow Schwalbe* 1995 (fig.53).

In Berlin, Orozco also made the sculpture *Horses Running Endlessly* 1995 (fig.26), a piece that explored his ongoing interest in games: the abstract and highly associative movement involved in sports and board games, as well as the social codes and national characteristics embedded within each culture's understanding of a particular game and its given rules. Chess has fascinated Orozco since he was young and he has made use of the movement of the horse or knight in a number of works. Orozco sees the knight's movement in chess as the only example of three-dimensionality in an otherwise two-dimensional game and has used this mental and physical image of movement in his painting and graphic production as well as in the sculpture *Horses Running Endlessly*, which features an enlarged chess-board with four times more squares, in four different shades of wood,

and occupied only by knights. Orozco's knights bring to mind a natural equestrian spectacle, leaping in curved lines across the chequered board whose tones match those of the knights. Without the king and his army the game is no longer, one imagines, a challenge to be won. But as with Orozco's other pieces that are based on familiar games and strategies, the absence of the normative rules and appearance instead invites us to consider what potential remains for playing this new configuration of 'wild horses' and what other goals could be identified. This type of mental projection or participation is an integral part of the artist's thinking. A consummate game player himself, much if not all of Orozco's work can be viewed from this perspective of inventing games, often from the simplest of means. Orozco's investigation of an as yet unexplored medium frequently begins by establishing a game-like set of rules or a playful approach to experimenting with a new terrain.

One exhibition in particular allowed Orozco to focus on the significance of games in local culture. Invited by the independent art commissioning organisation Artangel in 1996 to produce an exhibition in London, Orozco decided that he wanted to identify an empty gentlemen's club as the venue. Interested in both the history of these sites as well as their situation in the partly vacated centre of the city – a place at once occupied and empty – Orozco was not sure at first if he would place anything at all in the building or leave it, as the title in fact implied, as an *Empty Club* (fig.27). He has remarked on the process:

We looked for that type of building very hard – it was a very weird building and also very conventional of course. One aspect was the idea of the empty space in the centre of a city, how centres become empty at some point. The idea of emptiness in general in my work is important. At one point I was thinking about just leaving the building

EMPTY CLUB 1996 [27]
Installaton view, The Devonshire
Club, 50 St James's Street,
London, 1996
Commissioned by Artangel, London

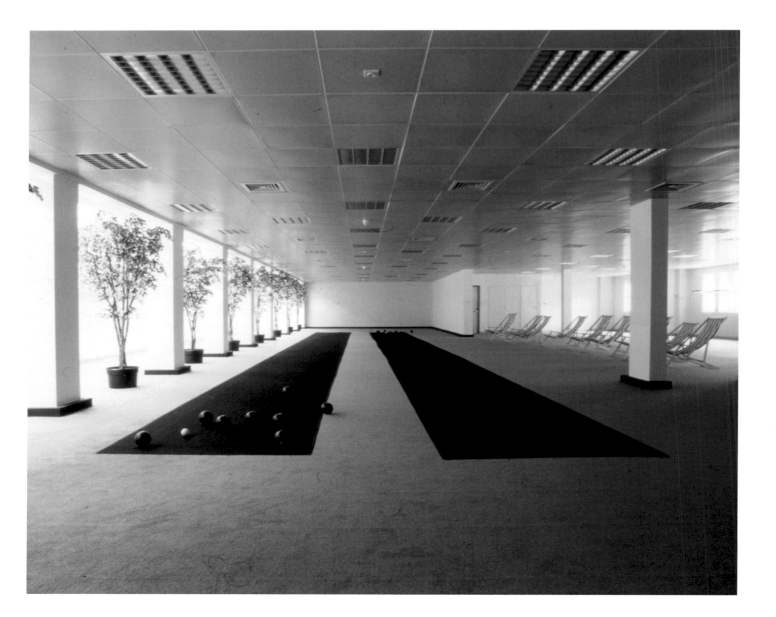

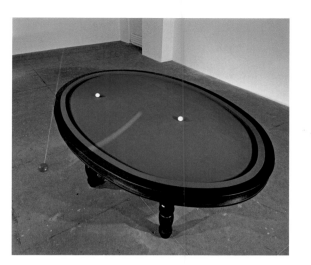

CARAMBOLE WITH PENDULUM
1996 [28]
Modified billiard table and
billiard balls
88.9 x 309.2 x 228.6

empty, just having it empty so people could come to see it as a ruin, as an empty kind of pyramid.

Situated off Piccadilly, the Devonshire Club, as it had been before its closure in 1976, had a previous life in the nineteenth century as William Crockford's (1775–1844) 'Temple of Chance', a gambling den. As such it represented the heyday of the British empire and the leisure domain of the landed gentry who were its members. Since the club's demise, the space had been entirely renovated, the historical rooms equipped with gaudy gilt plasterwork, busy decorative carpets and chandeliers, and the upper rooms had the look of standard office interiors of the time. Orozco proceeded to occupy the space with a sequence of sculptural and graphic pieces all of which addressed sports and games in one way or another. From cricket to football and billiards to bowling, Orozco set out to make an anthropological study of the UK through the engagement with sports, relating the concomitant interest in rules and regulations with British society's class system. Perhaps best known among the sculptural works on view in *Empty Club* was *Carambole with Pendulum* 1996 (fig.28), which was originally conceived for the elliptical Chapel de la Charité in Marseille, France. The piece was realised in London in part because Orozco found a billiard table manufacturer willing to take on the unconventional job. *Carambole with Pendulum* consists of an oval-shaped billiard table with no pockets and three balls – one red and two white – the red one being suspended from the ceiling by an invisible line of fishing wire and hovering miraculously millimetres from the surface of the baize cloth-covered table. Many of the characteristics of the work were based on the form of billiards known as carambole (also called French billiards), which Orozco played frequently in Mexico and Spain. The game consists of using one ball to hit the other two to make

a carambole. To play Orozco's billiard game it is necessary to try to activate the hanging red ball by hitting it with one of the whites, generating a pendulum effect that makes the ball swing and float out of the borders of the oval table. The new element of time included in the pendular ball generates a permanent state of movement around the space and largely undermines the calculations of even the most adept regular billiard player. It is now necessary to observe and calculate the appropriate timing to hit, in an exact moment, and catch the perpetually displaced red hanging ball. For the UK audience Orozco found that what was considered most striking about this altered game-as-artwork was not in fact the suspended red ball nor the rounded shape of the table itself, but rather the absence of pockets and the limitation to just three balls – features that are in fact common to every carambole table and thus no deviation from the norm.

As a sculptural work the piece achieves its ideal state only through the movement of the red ball, whose suspension and plumb line were inspired by the great height of the original Marseille chapel location. Orozco had thought of Foucault's pendulum and the possibility of revealing, through this newly devised game, evidence of the rotation of the earth. Once the balls are moving – the red ball swinging in an arcing pattern above the table and the white balls ricocheting around the oval of the table top – you can begin to see the myriad associations that the artist had in mind in addition to proving Foucault's theory. From the explosive bang of the balls that mimics the origin of the universe or the mechanics of an atom, to the rotating movement of planets and satellites replicated by the circulating balls, the billiard table functions on the one hand as a model of space, while on the other the manner in which the red ball cuts through the air suggests an automatic drawing similar to the *Breathing*

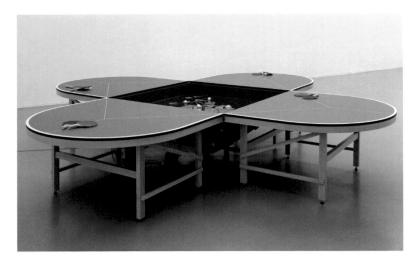

PING-POND TABLE 1998 [29]
Modified ping-pong table, water
lilies, soil, stones and water
76.2 x 426.1 x426.1
Edition 1 of 3

Drawings that Orozco was to produce in 2002, for which in one breath he allowed his hand to move with the motion of exhalation. As with many of the artist's most significant pieces, *Carambole with Pendulum* is one that slowly unravels through the projected interaction with the work's implied and real form. Beginning with the altered game, the associations gradually spiral out in connected, overlapping vectors of significance.

Other spaces in the club building were less atmospheric than the high-ceilinged nineteenth-century room that housed *Carambole with Pendulum*. The anonymous office architecture of the 1980s re-fit on the upper floors served as the setting for additional sculpture and graphics that explored the art of bowling as well as a model scale sculpture of a cricket pitch. Also on display were *Atomists* 1996 (figs.72–3), a series of large commercially printed works on paper, which depicted found photographs of sports images culled from newspapers that Orozco had collaged and printed over before digitally enlarging. Titled after the fifth-century BC Greek theory of matter, the word atomism derives from the Greek 'atomos' which literally means uncuttable. The abstraction of the semi-obscured images resembled the white discs that replaced some of the leaves on Orozco's sequence of office plants titled *Moon Trees* 1996, which bordered the bowling lanes that Orozco constructed and had been inspired by an experience of the eclipse. The occluded and interrupted forms and movement in *Atomists* drew attention to the manner in which sport would have been received by members of the gentlemen's club – as stationary observers – while the presence of the games referenced the previous life of the space as a gambling den.

In 1996, coinciding with Orozco's *Empty Club* installation, an exhibition of his work organised by Kunsthalle Zürich travelled to London's ICA. The exhibition included, in addition to *La DS* and *Elevator*, the artist's first *Working Tables* 1993–6, which on another scale also investigated the coming together of various small sculptures in an interconnected installation. Consisting of a large pedestal made at the same height as the table surface on which the artist typically works, it is the first example of this chronologically accumulative project (fig.30). Based on a number of unfinished or experimental investigations of objects and drawings in plasticine, paper and found materials that Orozco had been storing in shoeboxes in his apartment in New York, *Working Tables* suggested a field of ideas – notations, games, material gestures and small explorations into form, media and process. Placed all together in a horizontal configuration, the objects appear as finds from an archaeological dig, or treasures gathered in a personal collection of art: artefacts and found objects on a domestic table rather than the precious presentation of individual and discrete sculptural forms. There is, as with so many of Orozco's works, the intimation that a game might be played between the elements and the suggestion that they could be recombined in multiple configurations, providing alternative dialogues between the individual pieces. Reflecting on the origin of this presentation, Orozco has said:

It was a combination of everything. While planning my exhibition, Mendes Burgi, then the Director of the Zürich Kunsthalle, wanted to show all these small objects and drawings, kind of fragile, almost ephemeral pieces – small models and tests left over that I was keeping as a way of having them in case I needed them. So after we looked at all of them we decided to show them all together, instead of each one having a pedestal. And it was kind of a practical solution to make a big platform resembling a large table. Most of the work was made on a table in my apartment,

WORKING TABLES 1993–6 [30]
Mixed media
Dimensions variable
Installation view, Kunsthalle
Zürich, 1996

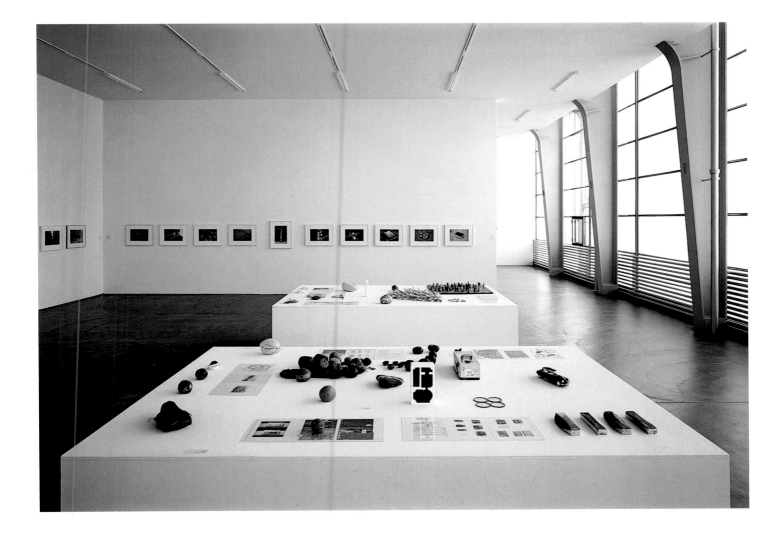

COLOR TRAVELS THROUGH FLOWERS
1998 [31]
Dye on paper
Dimensions variable
Installation view, *Gabriel Orozco:*
Clinton is Innocent, Musée d'Art
Moderne de la Ville de Paris, 1998

CLINTON IS INNOCENT 1998 [32]
Installation view of *Gabriel Orozco:*
Clinton is Innocent, Musée d'Art
Moderne de la Ville de Paris, 1998,
showing VENTILATORS 1997,
BLACKBOARD DRAWINGS 1997–8,
DANDELIONS 1998, and PINCHED
STARS 1997

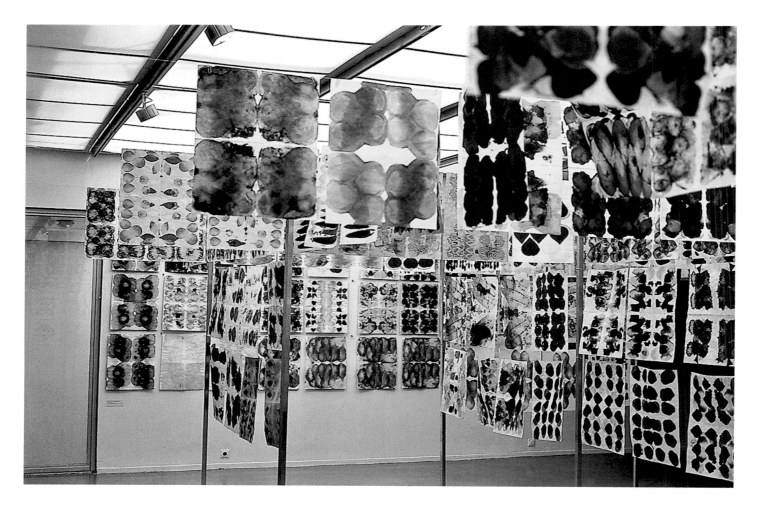

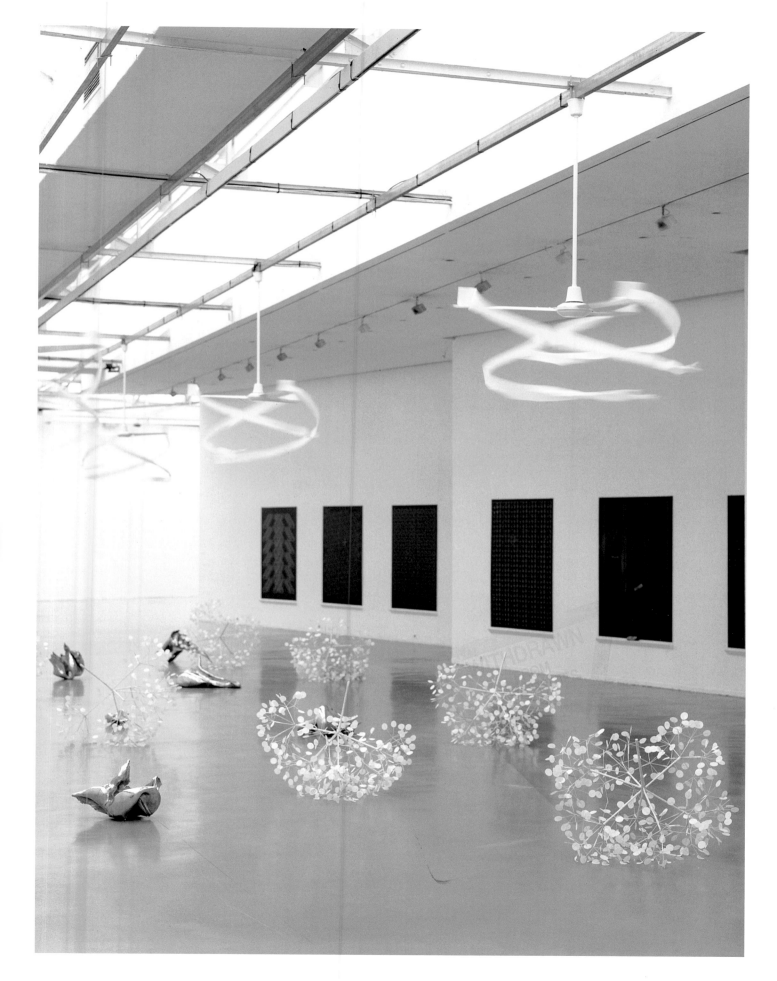

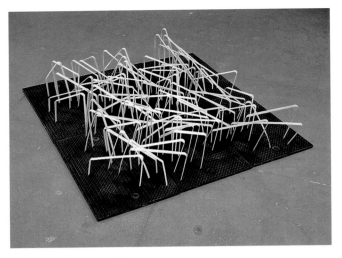

PENSKE WORK PROJECT: BLINDS
ON RUBBER MAT 1998 [33]
Aluminium and rubber
40.6 x 175.3 x 175.3

PENSKE WORK PROJECT:
BUCKET FRACTAL 1998 [34]
Three plastic buckets and garbage
52.1 x 58.4 x 58.4

*my desk was my working table for all these experiments.
The proportions of the platform to show them are related
to this and measurements are the height of a table.*

This type of non-hierarchical ordering was echoed
in the photographs that Orozco showed in the same
exhibition, documenting the various acts and
incursions into the landscape that had been captured
in a low-key manner and contained within the
photographic frame.

Following this major presentation of his work in
London at two sites, Orozco was invited for a solo
exhibition at the Musée d'Art moderne de la Ville de
Paris in 1998, where he further developed the open-
plan style of installation that has come to characterise
his exhibitions. The space of the Paris museum follows
a fairly unconventional semicircular plan and Orozco
occupied it with a sequence of works that incorporated
new game-based pieces such as *Ping-Pond Table* 1998
(fig.29) and the lightly ephemeral *Ventilators* 1997,
which features ceiling fans with rolls of partially
unravelled toilet paper placed at the tips of the fans
such that lines of paper mesmerisingly swirl around
belying their mundane origin. The exhibition began
with the show's title written in large text mimicking a
headline from the *New York Times: Clinton is Innocent*
(fig.32). Taking place right after the 'Whitewater'
political scandal promoted by the Republican party
and at the height of the news in which US President
Bill Clinton (b.1946) was accused of having 'sexual
relations' with his intern Monica Lewinsky (b.1973)
Orozco's reference was an ironic comment on political
stance and public judgements, in both art and media,
as much as on the banality and almost unavoidable
abstraction of political sentences once placed within
the art world. Of course this 'political' semiotic gesture
produced in Paris made evident the gulf in political
approaches, the French retaining an absolute divide

between the personal activities of politicians that are
considered to be private affairs and of no relevance to
their political position, as opposed to the American
system within which the lifestyle, beliefs and
domestic actions of the political personage are at times
considered of almost greater importance than their
convictions in a political arena. The exhibition drew
on Orozco's experience of Paris – where he had been
living intermittently for the last two years – including
his reflection on the art of fin de siècle France from
Erik Satie's music (played unskilfully by Orozco on
the piano in a recording that could be heard
throughout the exhibition space) to Claude Monet
(1840–1926), whose water lilies were present literally
in the centre of the *Ping-Pond Table* in a humorous
homage, as well as in paper form in the maze-like
installation of *Color Travels Through Flowers* 1998
(fig.31),comprising sheets of stained paper on which
had sat drying petals of dyed silk flowers that Orozco
had obtained from the manufacturer La Maison
Guillet. The curving walls of the gallery were echoed
in many of the works installed, from the rounded
edges of the *Ping-Pond Table* and the swirls of paper in
the air in *Ventilators*, to the infinity sign of the
suspended *Kiss of the Egg* 1997, a sculpture that called
for two viewers to simultaneously kiss the egg at the
centre, which would remain in place only if equal
pressure was applied to both sides. This careful
equilibrium was a feature of the entire exhibition that
delicately and yet forcefully conveyed Orozco's
unusual ability to move fluidly between materials,
methods and meaning, embracing simultaneously and
apparently without constraint traditional concerns for
colour and form as well as a highly contemporary
approach to inserting the real into the time and
information of the exhibition.

Visitors were encouraged to interact with the

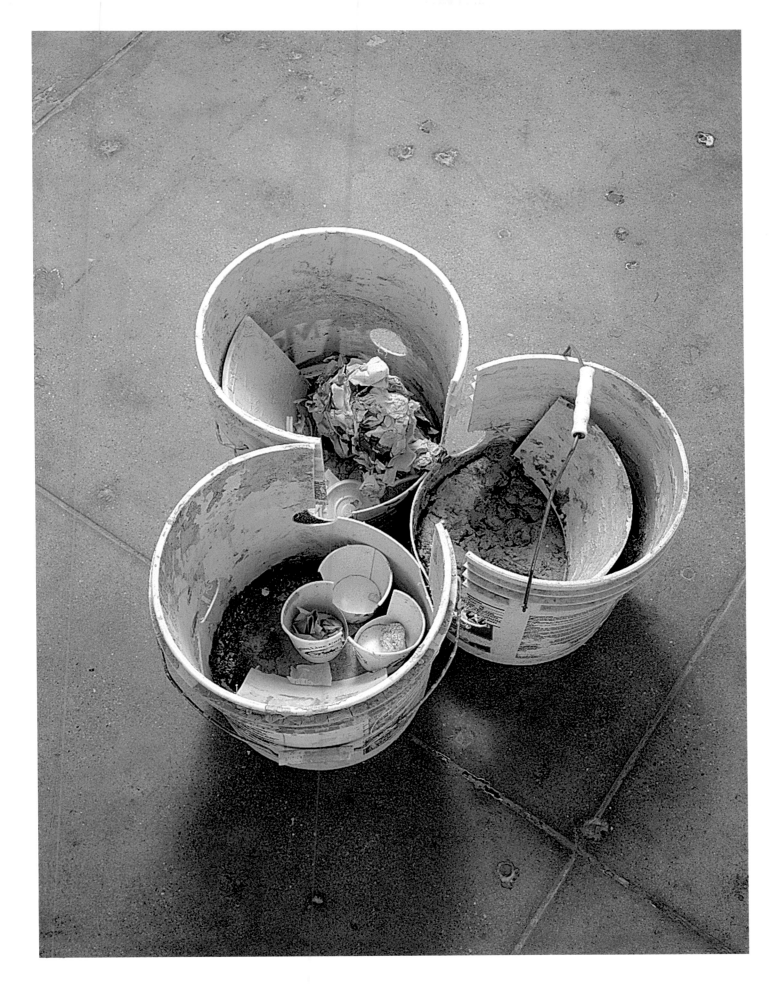

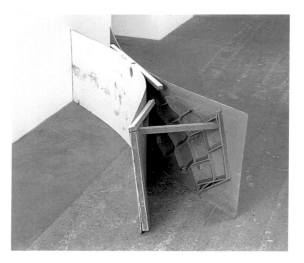

works in the Paris exhibition: Orozco's *Blackboard Drawings* 1997–8 (see fig.32) consisted of repeated geometric designs and grids – reminiscent of early computer games – developed digitally and transferred to the blackboard surface where viewers could draw or write over them; *Ping-Pond Table* challenged even the most expert ping-pong player to reconceive the space of the game, which now entailed four players and a central lily pond in the place of a net; while *Kiss of the Egg* had sticky consequences for those in too much of a hurry. Made at a time when the notion of participation was being explored by many artists of his generation in a manner that recalled the experimental sculpture and performances of the 1960s from Latin America – Lygia Clark and Hélio Oiticica (1937–1980) – and the US and Europe (Allan Kaprow (1927–2006) and Vito Acconci (b.1940) for example), Orozco's work also evinces an interest in altering the normative role of the viewer in the museum as well as drawing a parallel between activities of daily life and gesture with those encountered through his art. While Orozco's sculpture from this time in particular undoubtedly makes use of such strategies to engage the viewer, there is a marked difference between his approach and, for instance, that of his friend Tiravanija. Orozco's use of participation is carefully choreographed – the players of *Carambole with Pendulum* or *Ping-Pond Table* activate the pieces through interaction and without them the kinetic aspect would not be evident. Rather than the mass experience of Tiravanija, whose work always calls for 'lots of people', Orozco's sculpture functions like the actual intimate or personal games that he so often manipulates within a prescribed parameter. For Orozco, it is the tension between control and chance where individual interactivity has a place, rather than the collective experience of Tiravanija's cooking events. This idea

could be extended to a parallel between the role of self and Other in so far as Orozco's work suggests the desire to insert a dimension of interaction and with this the introduction of chance. His sculpture creates a dialogue that is then extended to the viewer through their real or projected participation and will only happen as a consequence of the spectator's initiative.

The game-based pieces that Orozco made during the mid- to late 1990s were in essence a logical extension of the small incursions that he had made into the landscape and photographed over the years, many of which are suggestive of the notion of turning the city or the immediate environment into a game of sorts. On returning to New York in the summer of 1998, Orozco continued to play with his immediate surroundings, but on this occasion, rather than abandoning the structures and assemblages made on the street and in the urban arena, he set out to make, document and then retain the materials for future exhibition. This process became the *Penske Work Project* 1998 (figs.33–5), named after the rental company that supplied the van in which Orozco drove around the city looking for refuse containers and abandoned materials with which to experiment. Orozco set himself certain rules for the works: all had to be completed right at the spot, in the street (some took a few minutes, others the best part of a day), and those that were unsuccessful or unsatisfactory had to be returned to the rubbish bin or contruction container from which they were scavenged. Orozco has said about the process of this piece:

The idea was to have a mobile storage unit, not so much as a workshop but as a place to put the work already made. I asked one assistant installer from the gallery to come with me to learn and help to make them. It was a lot of fun work everyday, going through containers of trash throughout Manhattan. I took basic

THE FREE MARKET IS
ANTI-DEMOCRATIC 1998–9 [36]
Installation view, Marion Goodman
Gallery, New York, 1998, showing
YOGURT CAPS 1994, PENSKE WORK
PROJECT 1998, PINCHED STARS 1997
and DANDELIONS 1998

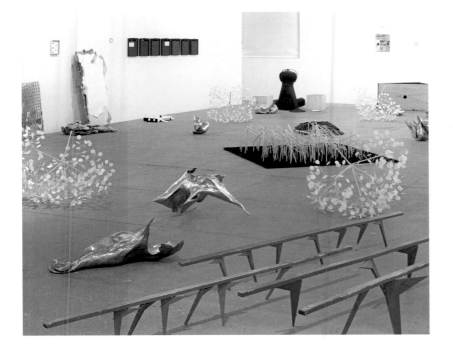

tools like a drill and a hammer and I had to come to a 'sculptural' solution right on the spot. And once it was made I took a Polaroid to document and to remember how it was made to reproduce afterwards in the gallery. I stored it in the truck, then I went on to the next container, and the next, and the next. I was looking for trash containers or cans or bags, then parking and making the piece right there on the sidewalk. It was very important that I had to do it right there. Not after. Sometimes they took half an hour or one hour, sometimes a whole afternoon. And sometimes they were too complicated and I put them back in the trash – there were so many failures. After a month the truck was full and I have all these Polaroids. I reassembled each piece and put them together in the gallery space as a kind of landscape …

The final result was exhibited at Marian Goodman Gallery in 1998 in an exhibition titled *The Free Market is Anti-Democratic* (fig.36). The *Penske Work Project* objects were combined with *Yogurt Caps* (as if they had never left the space), as well as some of the objects from the Paris exhibition. All installed in the gallery's main space, the horizontal field gave an impression not dissimilar to the *Working Tables*, the difference here being simply one of scale.

Orozco's *Black Kites* is a work that recalls the long tradition of memento mori in art. Although it is perhaps initially dissimilar to the game-based works and public interventions that he had been making, in many ways it is consistent with Orozco's ongoing fascination with the combination of geometry and chance, or the organic and the systematic. A feat of endurance in itself, with *Black Kites* Orozco set out to cover the contours of a human skull with a graphite grid (the grid used as an experimental platform in many of his drawings but also associated with that of the chessboard). Forced to adapt to the crevices, irregularities and rounded form of the skull, the standard squares are morphed and stretched into lozenges and curves, questioning our faith in the grid.

JESSICA MORGAN When you made this piece, were you recovering from an illness?

GABRIEL OROZCO Well, I think that the idea came a little before this. I was working on it and then I had a collapsed lung. It was this accidental thing that happened one morning, and apparently it happens to young, skinny, healthy men, and there is no reason for it. It was an accident. After a week in hospital I was convalescing at home and not wanting to go out at all, so I decided to do the drawing and to make it very slow, a very intimate work, an excuse to be alone at my desk – it was wintertime in New York. I spent some months doing this.

JM What was your reason for using the skull, which because it is a human skull is almost overloaded with meaning?

GO I wanted to live the experience. I wanted to see how the behaviour of a bi-dimensional grid on a very complex and real organic shape like that one would evolve. To superimpose two things that are kind of contrary: a very well-structured grid, a flat geometric structure, over an organic, super-complex form like a real – and 'accidented' – human skull. And I wanted to do this manually, personally. And this is not a mechanical work that you can do using a slide projector or the computer. Not really, because you need to encounter the real accidents that bone has and to confront them with the drawing grid, there are many accidents in every different skeleton. So carefully filling the pores of the bones with graphite was quite an experience. And I was very much face-to-face with death. It was intense to experience that.

JM Did you make it for *Documenta X*?

GO Absolutely. But it was kind of a secret. I told Catherine David that I was going to do something special, and I wanted to do it alone – it wasn't going to be a big public sculpture in the street, it was going to be a small but powerful object. So she was just quietly waiting for it. Then, two months before the opening, I showed her the piece when she came to New York to see me. Her eyes wide open she said, 'Ah, il m'a donné une tête de mort! Il m'a donné un mort!' She was screaming to her assistant, 'Ah, he's given me a skull! He's given me a dead person!' I didn't realise that to French people it would be a very shocking thing to deliver a head to *Documenta*! I myself was a bit scared, at the time. I remember,

when I finished, I thought it was kind of horrible, really weird and strong, a shocking thing. I couldn't see it any more so I put it in the closet and left it there for a few weeks.

JM Because of the nature of the material, the viewer is very aware of your act of making it. And there is drama in the work. Is it a dramatic piece?

GO I don't think it's dramatic. I don't believe that I have tried to be spectacular. I don't think reality is spectacular, per se. I think it depends on your perception of what is spectacular: you know, a flower or a small insect can be spectacular if you look at them in a certain way. I think that *La DS*, *Black Kites* and a few of my other works are spectacular as a side effect, as a poetical accident.

JM You have always avoided an over-association in your work with being typically or overtly 'Mexican' but of course you must have known that *Black Kites* would be seen as related to the skull as a motif within Mexican cultural history. Was that something you were thinking of?

GO Well, I was aware of it of course, and I was laughing about it too. I thought 'Yeah, well, they will probably immediately connect this with Mexican art.' But I was not at all thinking of Mexican *calaveras* in that way. I was doing my own experiment with graphite on real bone. And I knew that the connection with a Mexican tradition would be there, especially in the context of the grand western European mother of all shows like *Documenta*. But I also knew that some curators like Catherine and some artists will know that there is a whole world to be explored in the field of the memento mori. We can also easily think about the meaning of the skull in western art in general, or in Indian art in particular, which is so important in all of my work. Or in heavy metal band souvenirs if you look on Bleecker Street, around the corner from my house! It's everywhere in fact. But I do believe that the real impact, or shock of *Black Kites* in the art world didn't rely on the Mexican connection at all. That work really touches some nerves in the structured brain of the one who gets in front of it. That's why it works! And that's it for me.

BLACK KITES 1997 [37]
Graphite on skull
21.6 x 12.7 x 15.9

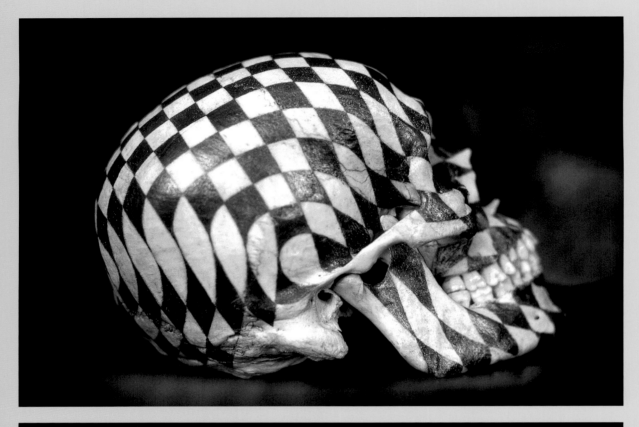

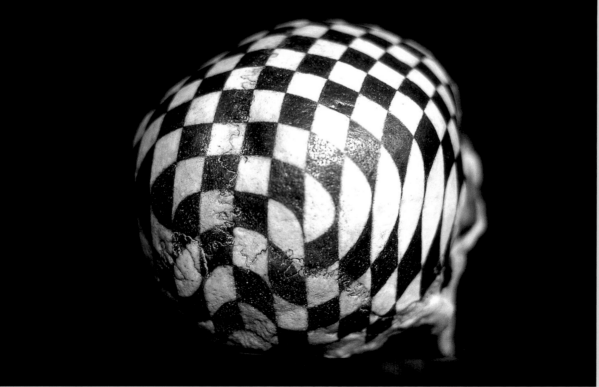

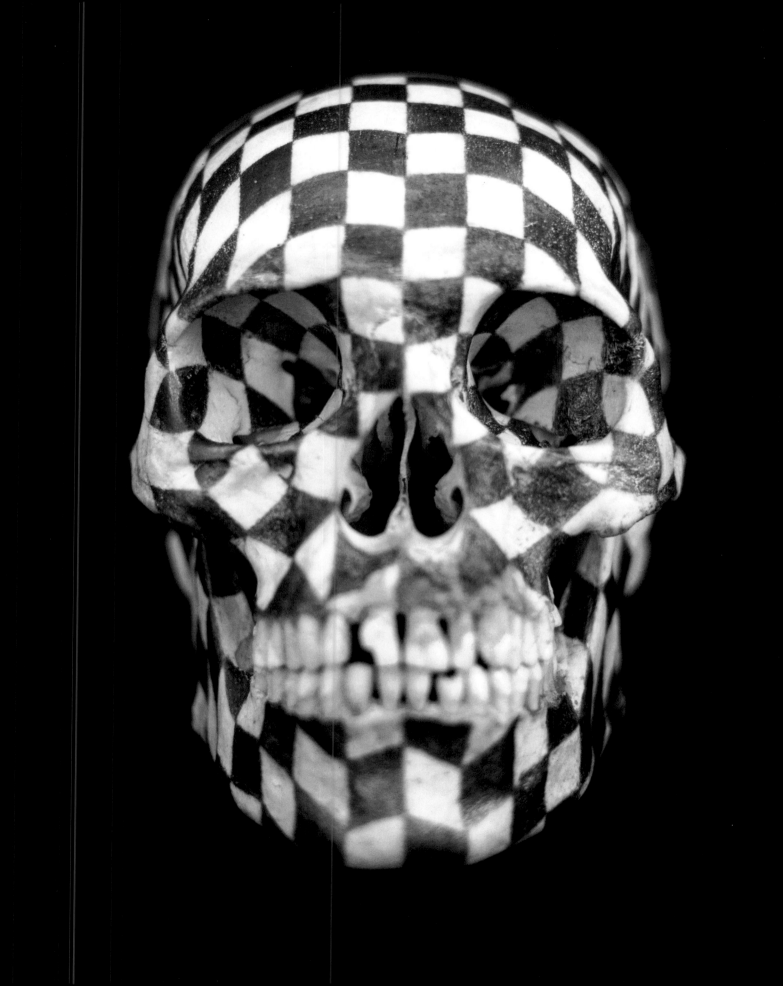

RUBBED BRICKS
1991/2002 [38]
Chromogenic colour print
40.6 x 50.8
Edition of 5
85.7 x 118.8
Edition of 3

4

It is perhaps illogical to separate out for discussion the photographic oeuvre of Orozco. His photography is after all intimately connected to the other aspects of his practice and in many respects is a direct extension of his activities as a sculptor. Nevertheless, Orozco's photographs have, independently from his other work, influenced the genre over the last two decades and we can see clearly the impact that his particular approach has made on practitioners more closely aligned with the specifics of the medium. Orozco's photographs can be crudely summarised as falling into two general categories: those that capture the artist's interventions in the everyday environment, and the body of images that consists of snapshots arresting for perpetuity what he sees in nature and the sensible world around him. Orozco himself has referred to his photographic work as a vessel or a container, down-playing the role of photographic object and emphasising instead its purpose as a visual record. His first photographic experiments were made in Spain while he was a student in Madrid, using a friend's camera to document a few of the pieces he had made as temporary interventions in the public realm. It was not until Orozco returned to Mexico at the end of the 1980s, however, that he began to pursue this practice of archiving his sculpture through photography with some consistency. Referring to the role that photography plays, Orozco is adamant about the difference between his approach and that of documentary photographers. He says:

One aspect of my photography was recording my interventions in the street, walking and playing with objects, and the photograph became this way of sketching out things and archiving them. But with the actions in the street, I was active, I was not just documenting: I was doing, I was making things happen. So it's not like I was just documenting as a spectator; I was provoking and *then photography was a substitute for the notebook in which I write and archive or store my ideas and experiences. Sometimes I also say that my photographs are like shoeboxes. They are containers that have these action phenomena or experiences in there. I do believe that when you see my photos, you don't think you are just looking at a photograph.*

Early examples of Orozco's documentation of interventions include *Rubbed Bricks* 1991 (fig.38), a residue of an action that he made on an abandoned plot of land in Mexico close to his studio. The artist employed the clay bricks, presumably found on the site, first rubbing them together to create powdery aureoles at the tops of the small hills that articulate the landscape of the plot, then placing a single brick on the top of each hill demarcating the receding view such that we must look carefully to identify the furthermost bricks on top of their mini mounds of earth. The image is typical of Orozco's tendency to create all-over landscapes or installations of the sort that he developed in *Working Tables*, the *Penske Work Project* and elsewhere. Bringing to mind a cosmic array, this type of arrangement is also suggestive of a net or network of interrelated forms that could be compared to map-making, a game board or even the visual documentation of some structural organisation, be it a mind map of intellectual thought or the business organisation of a corporation. It is a tendency that also undermines the notion of a central subject instead diffusing attention from the centre to the periphery, creating one horizontal platform as opposed to a hierarchical structure and thus functioning as a metaphor for Orozco's interest in decentring place and site, and questioning the dichotomy in artistic terms of centre and periphery, first and third worlds.

Representing the alternate strain in Orozco's work of capturing found moments and readymade

WELL 2002 [39]
Chromogenic colour print
40.6 x 50.8
Edition of 5
85.7 x 118.8
Edition of 3

COMMON DREAM 1996 [40]
Silver dye bleach print
40.6 x 50.8
Edition of 5

SLEEPING DOG 1990 [41]
Silver dye bleach print
50.8 x 40.6
Edition of 5

Overleaf:
HORSE 1992 [42]
Chromogenic colour print
50.8 x 40.6
Edition of 5

TORTILLAS AND BRICKS
(TORTILLAS Y LADRILLOS)
1990 [43]
Cibachrome
50.8 x 40.6

situations in the environment is the early photograph *Sleeping Dog* 1990 (fig.41), an image so compelling that it is difficult to resist the urge to reach out and touch what we imagine will be the soft, firm body of the dog. The dog's peculiar choice of resting place, asleep, apparently at a sharp angel – though this could also be a trick of the camera – on the rough rock surface of some unidentifiable location, momentarily raises the question of whether it is still alive or if this is in fact a peaceful vision of a public death. The title of the piece belies this possibility and once acknowledged it is impossible not to imagine that we can actually make out the furtive breath indicated by the stomach of the dog rising and falling and even to project the odd twitching of feet and whiskers that typically accompanies an animal's dream-ridden sleep. Other animals have featured in Orozco's work, similarly taking on a sculptural form that is at once intensely tactile and formally suggestive. The more austere image, *Horse* 1992 (fig.42), abstracts the animal's rear end and tail creating from it a sexually suggestive split oval similar to the shape in *Well* 2002 (fig.39) captured years later on a trip to Mali. *Common Dream* 1996 (fig.40) meanwhile, like the naturally occurring sculptural form of the sleeping dog, shows a huddling group of sheep sheltering their young from the sun. Their softly interlocking woolly white bodies merge together creating one undulating mass not entirely unlike the heart-shaped compression of *My Hands Are My Heart* (figs.7–8). Such correspondences between found situations and Orozco's own, often quite intuitively made sculptural work are perfectly summarised by Buchloh, who observes in his essay on Orozco's photography that his images suggest that sculpture is 'a naturally occurring phenomenon'[10] waiting for the attention of the artist to record them in time.

This capacity to identify or create – from the slightest gesture or the simplest observation – reverberations of meaning in his photographic images has been eloquently described by Bourriaud:

When Gabriel Orozco puts an orange on the stalls of a deserted Brazilian market (Crazy Tourist 1991) *... he is operating at the hub of 'social infra-thinness'* (l'inframince social)*, that minute space of daily gestures determined by the superstructure made up of 'big' exchanges, and defined by it. Without any wording, Orozco's photographs are a documentary record of tiny revolutions in the common urban and semi-urban life (a sleeping bag on the grass, an empty shoebox, etc). They record this silent, still life nowadays formed by relationships with the other.*[11]

Perhaps one of his best-known images, *Crazy Tourist* 1991 (fig.46), was made by Orozco on a trip to Brazil with his future wife Maria, at a point when he had been able to obtain a small enough automatic camera to be carried around unobtrusively. At the end of the day the market was empty and Orozco used a pile of discarded rotting oranges to create the landscape that so clearly resembles the action of *Rubbed Bricks* made earlier in 1991 in Mexico. Placing the orange circular markers on the tops of each table, Orozco similarly demarcated the receding view and here set up a visual game of trying to identify the increasingly tiny specks of orange denoting a table surface. The circularity of the fruit and its noticeable colouring act as bold visual markers, again suggesting the overall pattern of a celestial sky. Here, as alluded to by Bourriaud, the market context and the discarded product bring to mind the system of exchange and transportation that established the value (and then lack thereof) of the oranges. A system or network so much more complex than the apparent simplicity of the local market situation and yet one of which we are

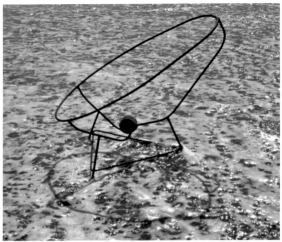

SANDBALL AND CHAIR I
1995 [44]
Silver dye bleach print
40.6 x 50.8
Edition of 5

SANDBALL AND CHAIR II
1995 [45]
Silver dye bleach print
40.6 x 50.8
Edition of 5

only too well aware has infiltrated this sphere of apparently uncorrupted commerce as thoroughly as it has manifested itself in the stock markets and digital transferral of wealth associated with the western economy.

The circular shape is repeated throughout Orozco's oeuvre – from the rolling *Yielding Stone* to the organic circles of the oranges in *Crazy Tourist* and *Home Run* – but as a motif it is perhaps never more present that in Orozco's photographic work, where the circle, both fabricated and natural, seems to populate the artist's surroundings in an endless multitude, arguing in a self-made manner for the total centrality of this form in all aspects of our life and thought. Works such as *Tortillas y Ladrillos* 1990 (fig.43) and *Sandball and Chair I* and *Sandball and Chair II* 1995 (figs.44–5) record the artist's interventions, the former suggesting anthropomorphic tortilla-heads placed on top of piles of bricks, while the latter show a fortuitously found Bertoia-like chair, reduced to its skeletal circular state, in the centre of which the artist has placed a carefully moulded ball of sand acting as the centrifugal force in this readymade sundial or diagram of planetary movement. Brett has eloquently summarised the manner in which this back and forth between the found and the fabricated in Orozco's work is by extension a metaphor for the development of life and thought. He says: 'Jean Fisher's encapsulation of Orozco's process as "a meditation on the act of making" could be expanded and reciprocated to include "a meditation on the act of being made." All the objects or situations in the street that seem to be objectified by the artist are simultaneously creating him.'[12] We are implicated in this discovery of magnitude in the everyday, the artist's physical absence (and for that matter the absence of any human presence) allowing us to occupy the space of observer or discoverer. Orozco's own fascination with a given situation by extension becomes ours to the point that even the weight and feel of the sandball seem oddly familiar and present as we observe the image.

The circle motif in Orozco's photographic work is perhaps most noticeable in the many images of water: reflections, puddles, rings on the surface. *Extension of Reflection* 1992 (fig.47), made on the East Side River in New York, documents the artist's circular movement through puddles of water, the black lines on the asphalt acting to extend the branches of the tree reflected in the surface of the puddle on the right and connect them to the wire fencing on the left. The small miracle of the reflection appears to make the flat ground three-dimensional – sky and trees magically seem to reach below the surface and question the solidity of the ground upon which we walk. The effect of the reflection also reminds us of the position of the world. The centrifugal force that binds us to the surface of the earth and convinces us of the planar quality of our movement across the terrain is questioned by this intrusion of the spatial dimension of the universe. Orozco inverts above and below and with that opens a chasm in our necessary belief in a lie and yet the end result is not one of horror vacui but rather wonderment at the possibility of it all. A similar reversal is implied in *From Roof to Roof* 1993 (fig.48), an image in which Orozco has captured the flooded roof of a building below where he is situated. The massive reflective pool has a silvery surface unlike the perfectly clear image represented in the water of *Extension of Reflection*. Circular rings spread out across the surface, their cause unknown (though we suspect the artist may have been involved in the game) and the title suggests an almost comforting encapsulation between the ground on which we live and the cloudy sky roof above us. Rather than having

CRAZY TOURIST 1991 [46]
Chromogenic colour print
40.6 x 50.8
Edition of 5

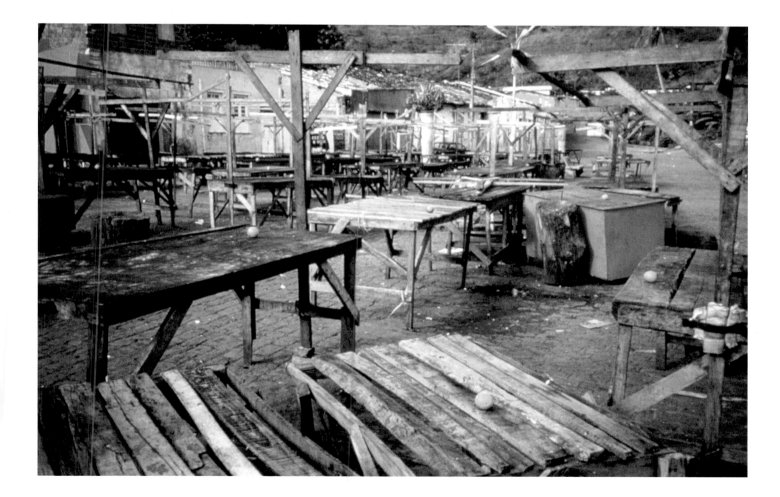

EXTENSION OF REFLECTION
1992 [47]
Chromogenic colour print
40.6 x 50.8
Edition of 5

FROM ROOF TO ROOF 1993 [48]
Silver dye bleach print
40.6 x 50.8
Edition of 5

the ground taken from under our feet, we are led to believe that we are protected within this layer of above and below.

Circles are created by the actions of a dog wagging its tail in *Dog Circle* 1995 (fig.49) and in the instinctual construction of a bird's nest in *Big Bang* 1995 (fig.50). Human activity is also responsible for their appearance in *Waiting Chairs* 1998 (fig.51), an image taken in a museum in India of moulded plastic chairs above which appear small aureoles of grease, the residue from the many backs of heads that have rested on the surface. It is an image that Buchloh has also read as an indictment of modernist hope:

These biomorphic Eames derivatives in the lobby of a museum in Calcutta at one time certainly held the promise of a better everyday life with which design deceived us into accelerated consumption. Now, in Orozco's photographs, these chairs are surmounted by greasy haloes, the imprints of heads. And the pointless passing of time that the imprints have recorded stands in diametrical opposition to the pathos with which design once promised new forms of everyday life.[13]

Buchloh sees Orozco's images of the many locations to which he travels – India, Mali, Mexico and so on – not as images of 'geopolitical spaces where the rules of universal reification have not yet taken hold', but rather that Orozco, while,

looking backward at these images of the pre-industrialist past ... seems to uncover their fate of being slated for an inexorable delivery to the very same principles of ecological devastation and the most ruthless forms of the exploitation of all available resources ... The continuously traveling artist, while not the perpetrator, is certainly the involuntary witness and messenger of that erosion.[14]

It is difficult to balance the drastic vision that Buchloh applies to Orozco's images of Mali with the serenity and extraordinary simplicity that Orozco captures in the *Cemetery* series 2002 (figs.1 and 52) and in *Total Perception* 2002 (fig.6). In all these images, by some unexpected karma, Orozco seems literally to find a reflection of his own work or rather perhaps he discovers the origins of his own thinking. In *Cemetery*, the earthenware pots that litter the burial ground marking the remains of those laid to rest underneath summarise Orozco's insistence on the importance of the circle, their irregular placement in the sandy landscape creating the all-over patterning that is such a frequent feature of his work, and the striations on the surface of the pottery further enhancing the comparison to orbiting planets. *Total Perception*, an image of an ancient mosque in Timbuktu, constructed from the most basic mud walls and woven fibre ceiling supported by branches, is peppered with bright circles of light beaming through the holes in the ceiling creating circular metaphors of enlightenment.

DOG CIRCLE 1995 [49]
Silver dye bleach print
40.6 x 50.8
Edition of 5

BIG BANG 1995 [50]
Silver dye bleach print
31.6 x 47.3
Edition of 5

WAITING CHAIRS 1998 [51]
Silver dye bleach print
40.6 x 50.8
Edition of 5

Overleaf:
CEMETERY (VIEW 1)
2002 [52]
Chromogenic colour print
40.6 x 50.8
Edition of 5
85.7 x 118.7
Edition of 3

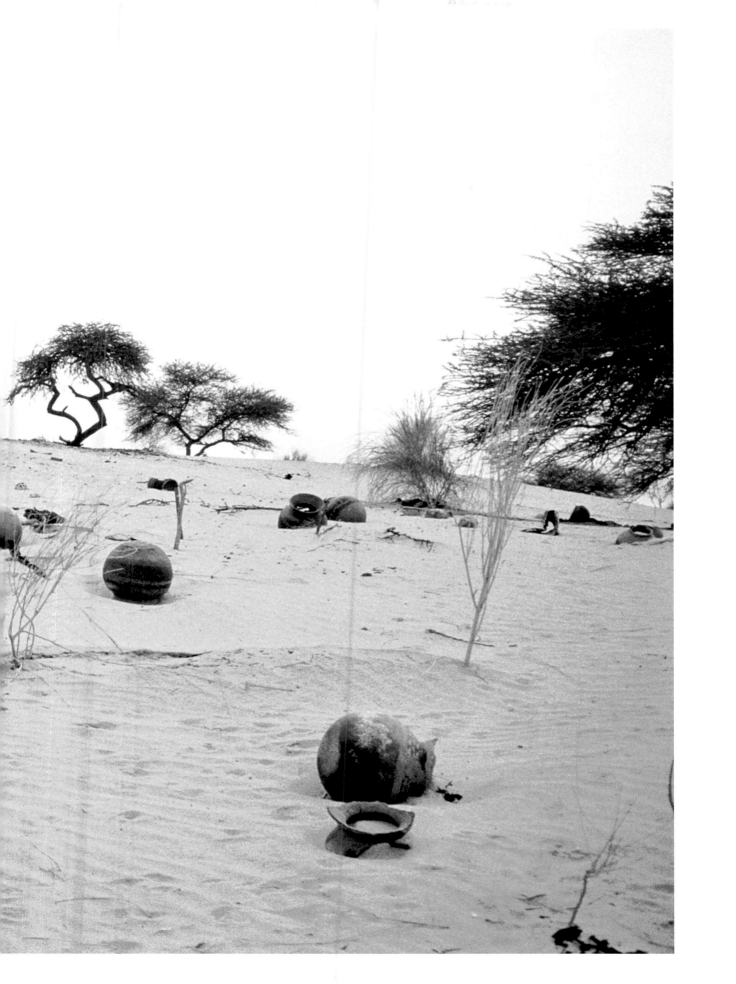

JESSICA MORGAN Did you look at other photographers' images when you were beginning to produce photography?

GABRIEL OROZCO Not exactly. Well, I did try to get away from photojournalism. I mean, many of the parents of my friends were photographers and photography was a very strong discipline in the 1980s. I would say that photography was a much more interesting art form in the 1980s than painting or sculpture in Mexico. And there was a group of people in my generation trying to do very serious photojournalism. So I was trying to do it differently, because it is not that I wanted to be a photographer – on the contrary, I didn't want to use photography, in a way, but then I had to do it, there was no other way, because I needed to make this type of sculpture. So photography became the tool that I needed and I adopted to finalise and realise my sculptural work. So that's why I like to talk about my photography as a recipient or as a container, a kind of shoebox, in tri-dimensional terms, because I want people to understand the difference, on how it's not just a visual document but more like a sculptural tool for me.

JM *Until You Find Another Yellow Schwalbe* is one of the few series of photographs that you have made.

GO I did this, the *Yellow Schwalbe* project, when I was riding a yellow scooter in Berlin when I was living there. I started to go around and people were saying hello to each other if they had a Schwalbe. So I started to go around looking intentionally for another one, that was the same colour and parked. And if I found it I would park next to it, take a picture, and keep going. So it became a board game in the city. And the photography was the way of recording this kind of ongoing board game round the streets. I collected, over two or three months, forty photographs.

JM Game playing and games have featured in your work a lot. Did this begin as a game or did it become a game?

GO It became a game. I saw these little motorcycles and I liked them, I liked this model from East Germany. It was very cheap and it was easy to run. But when I was using it I discovered there was a kind of communication between the owners of Schwalbes. So then I decided to invent this game … it was a chance to play around in my new environment and start to behave in a different way. I was in Berlin and I didn't have many friends so it was my excuse to go out solitarily and treat the city like a game board. If you think about it from a bird's-eye point of view, and the grid of the city is the grid of the board, then you can imagine Berlin from above and try to connect one motorcycle looking for another one, almost like a Pacman computer game.

JM And from the game developed the idea for the reunion?

GO I needed a happy ending and thought about this impossible absurd meeting. I started to leave a printout – Berlin was full of printouts circulating inviting people to all kinds of rave parties – in which I was inviting yellow Schwalbe owners to come to a 'massive' demonstrative reunion coinciding with the sixth anniversary of

the reunification of Germany that was still so much in the air … And so I invited them to come to the Neue Nationalgalerie's parking place to meet. The truth is that I wasn't expecting that much of a crowd to show up, as I would leave the printout on the motorcycle without talking to anybody. But yes, two did. I greeted them with joy, refreshments and cookies. It was a little bit of an understated gesture in a city quite disoriented in the process of understanding itself after the Berlin Wall fell … for everybody.

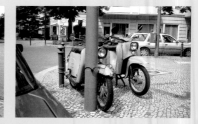
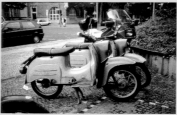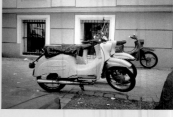
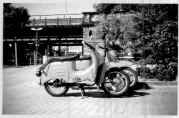
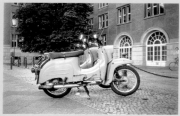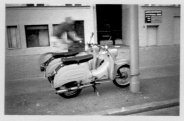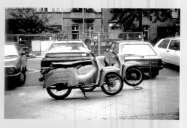
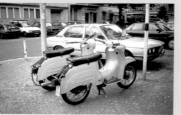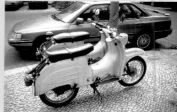

UNTIL YOU FIND ANOTHER
YELLOW SCHWALBE 1995 [53]
Forty chromogenic colour prints
Each 31.6 x 47.3

 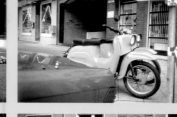 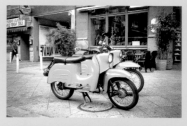

 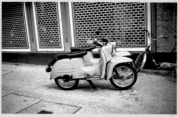 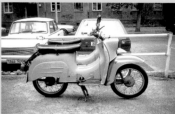 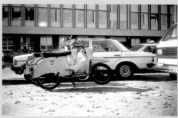

 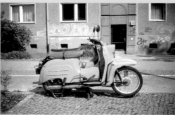

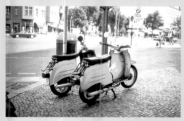 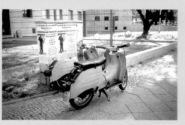

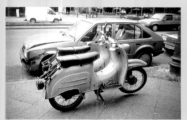 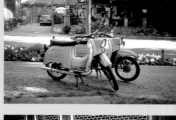 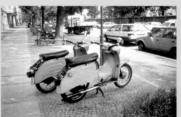

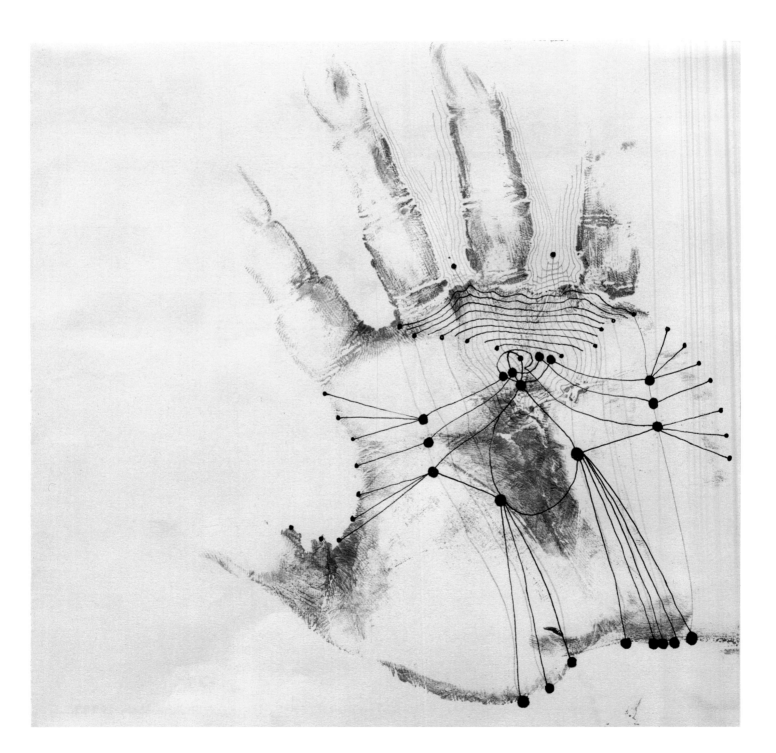

UNTITLED 2000 [55]
Graphite and ink on paper
28.9 x 21

DRAWING

Although Orozco is well known now for his drawings and works on paper, the formal presentation of this medium did not appear in his exhibitions and publications until the late 1990s. Before that time he thought of his drawings as experiments, explorations of ideas, but not to be exhibited. Orozco has said of this time:

I was showing just objects and photographs. Photography for me is also a way of drawing, it's like sketching out from reality, taking inspiration from things. But still I was doing drawings, always in the same size, A4 office-size paper – most of my drawings from 1991 until today are A4 – I love the idea of office work as a kind of 'drawing office work'. But gradually I also started drawing projects on other kinds of paper …

I was continuously drawing but not so much like art: more like exercises for me, cleaning out my brain, having fun, relaxing my brain. And I always stored them in shoeboxes, because I thought that it would be nice one day to go back to see what they were. Most of these drawings were on their own, independent from my other work. When I was doing a sketch to make a work, I'd put that in my notebook. But all these A4 works were on their own, accumulating in boxes. When I had nothing to do I would start to make them, mechanically …

The first series that Orozco consciously exhibited were the drawings that he made in Costa Rica in 2000 and 2001, while his wife Maria was undertaking ecological research and fieldwork there. These drawings continued the artist's use of the handprint or outline – a feature of *My Hand is the Memory of Space* (fig.15) and *My Hands Are My Heart* (figs.7–8), both 1991 – while also reclaiming a childhood project or game, in this case drawing around the outside of the hand placed flat on a piece of paper. The hand print drawings, titled *Fear Not* 2001 (fig.56) – the title references the saying of Buddha while showing his raised palm 'fear not, I will protect you' – make a visual parallel between the lines on the palm of the hand and the veins on the leaves of a tree. Of equivalent scale and structure, the palm/leaf hybrid seems to reflect the extraordinary fecundity of the rainforest in Costa Rica where the vegetation threatens to encapsulate everything in its path and any manmade incursion is rapidly reappropriated by organic growth. Orozco's hands, or at least their leaf-like impression on paper, are being absorbed into the land. Other drawings from this time, such as *Untitled* 1999 (fig.54) , *Untitled* 2000 (fig.55) and *Untitled* 2002, play with Swiftian shifts in scale and draw an analogy between the lines of the palm and the contour lines of an elevation map, as if the raised parts of the palm could be scaled up to the size of hills and valleys. In *Fear Not*, Orozco creates a new terrain between two fingers, the contour lines suggesting a steep ravine between the digits while the dots and straight lines traversing this space delineate a navigator's suggested crossing points.

In fact, preceding the presentation of *Fear Not* at Marian Goodman Gallery in 2001 (the title also referred to the palpable fear in the city post 11 September), Orozco had made other bodies of work that could be categorised as drawings. Among them are the collages that comprise the *Atomists* (figs.72–3) series – although at the exhibition *Empty Club* (fig.27) in 1996 Orozco showed only the large-scale prints of these works, he had in fact created, from English newspapers, these small-scale collages on which he had made the original print and wash incursions over the sports photographs. In addition, he had been making many versions of the computer printout patterns that provided the framework for the geometric forms on which *Atomists* were based but which here, in a series titled *Puddle* 1996–7 (fig.57), Orozco used to create all-over patterns that he then

FEAR NOT 2001 [56]
Synthetic polymer paint
and felt-tip pen on paper
27.9 x 21.6
The Museum of Modern Art,
New York. The Judith Rothschild
Foundation

PUDDLE 43 1996–7 [57]
Synthetic polymer paint and
graphite on ink jet print
27.9 x 21.6

filled in and overpainted, playing with the grid of the design as if with a self-generated game board. These, again A4-size, drawings play with the process of order and disorder created in the tension of the apparently programmatic design (in fact created by the artist) and the surface disruption of colour. The repetitive graphic support of the *Puddle* works in turn recalls the much earlier drawings (that remained stored in a shoebox until a later date) titled *First Was the Spitting I–IV* 1993, (fig.59) which were made on graph paper and which here provided the grid background. Orozco's process was to combine the gestural and relatively uncontrolled act of spitting toothpaste onto the graph paper and subsequently adding ink drawing that responded to both the found grid of the paper and the circular forms of the toothpaste. *First Was the Spitting* feels close to the sculptural actions in the public realm that Orozco frequently photographed, with the drawings being lasting objects as opposed to the indexical photographic print.

The circles and surface disruption of the *Atomists* series, which Orozco has consciously related to the graphics and photography of Aleksandr Rodchenko (1891–1956) and the visual conflict and interruption used by early twentieth-century photomontage, were further explored in works that originated when the artist started to draw on rupee notes and other currency during a trip to India in 1997, for example, *One Hundred Rupees* 1997 (fig.58), and on airline tickets (*Korean Air* 1997, fig.60). While the currency is painted over with gouache in much the same way that Orozco set out to create tension through partially obscuring the image in *Atomists*, the airline tickets are sometimes also incised with a compass knife with circular sections cut out and displaced, creating rings of partial information. Both series were in accord with the itinerant activities not only of Orozco but also of

so many fellow artists at this time whose on-the-go production had moved irrevocably away from the traditional studio-based activities that had been the original subject of critique by artist Daniel Buren (b.1938) in his now legendary text from 1970, 'The Function of the Studio'.[15] Artists of Orozco's generation were the first to participate in the creation of a truly global art world. Their presence was requested at biennials and large-scale exhibitions around the world and projects included were often made on site in response to the experiences of these artist-travellers. Purely as a document indicating Orozco's movement, the currency and airline ticket pieces were apt. However, within his oeuvre they also returned the subject at hand to the somewhat hidden process of circulation by which money, commodities and labour were being transformed into a capitalism that recognised no borders and was characterised by multinationals, digital communication and migrant workers. Orozco's pieces enveloped both micro and macro in their small-scale form, the process of incising and overpainting demonstrating the ever-increasing number of overlapping vectors that went to make up this new economy.

The same technique was applied in a more formal manner to the images of Japanese suizeki, or scholar rocks, in the *Eroded Suizekis* series 1998–2002 (figs.61, 65), and to reproductions of the monochrome works of Ellsworth Kelly (b.1923), *Kelly Kites* 2001 (fig.66). While the geo-political associations of the currency and airline tickets are absent from these pieces, they affect a different form of change on their subject. The organic, naturally eroded shape of the suizeki is contrasted with the geometric cuts that Orozco performs such that natural and mechanical attrition are contrasted. For *Kelly Kites* the cuts and rotations are perhaps less substantial but for such minimally

ONE HUNDRED RUPEES
1997 [58]
Gouache and graphite
on banknote on paper
27.9 x 21.6

FIRST WAS THE SPITTING I–IV
1993 [59]
Ink, graphite, and toothpaste
spit on graph paper
Each 41.9 x 32.4

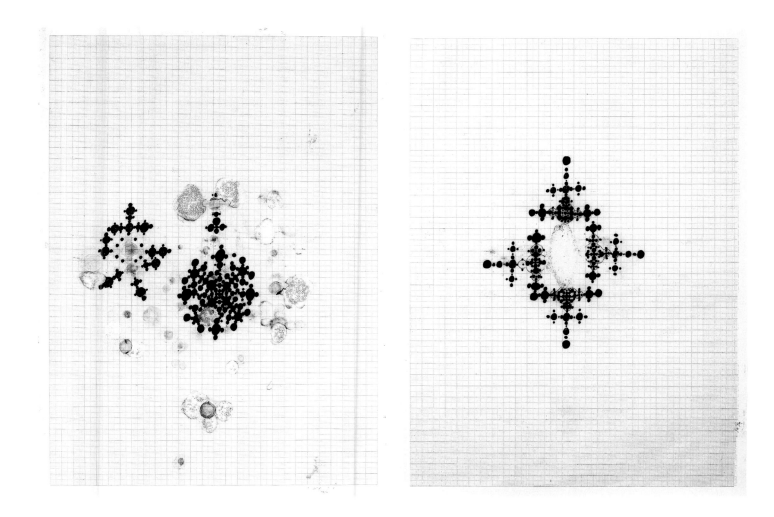

KOREAN AIR 1997 [60]
Ink and coloured pencil on cut-
and-pasted printed paper on paper
27.9 x 21.6

ERODED SUIZEKIS 25 2002 [61]
Cut-and-pasted printed paper
28.6 x 20.6

HAVRE-CAUMARTIN #20 1999 [62]
Graphite or charcoal on paper
200 x 100
Frottages from the walls of the
Havre-Caumartin metro station
in Paris
Courtesy Galerie Chantal Crousel

HAVRE-CAUMARTIN #5 1999 [63]
Graphite or charcoal on paper
200 x 100
Frottages from the walls of the
Havre-Caumartin metro station
in Paris
Courtesy Galerie Chantal Crousel

FINGER RULER II 1995 [64]
Graphite on paper
29.5 x 21

ERODED SUIZEKIS 1998 [65]
Cut-and-pasted printed paper
28.6 x 20.6

KELLY KITES 2001 [66]
Cut-and-pasted printed paper
29.8 x 24.1

conceived works the effect is no less radical. Aiming to disrupt the 'heavy phenomenological pretension' of the American minimalists, Orozco magically transforms the *Kelly Kites* into images that resemble more closely the investigations of Brazilian neo-concrete art such as that of Lygia Clark and Lygia Pape (1927–2004). He affects a kind of self-cannibalism of abstraction while at the same time perhaps recalling the more lyrical and playful pieces of Kelly, such as his overpainted postcard series (1949–84), which used the contrast of monochromatic paint to occlude part of an image of a city or site, flattening the area and creating a spatial confusion. These postcards in fact have strong ties to the work of Orozco and bring full circle the notion of disrupting the surface of the Kelly reproductions.

Other drawings that preceded *Fear Not* include those that were established according to a game or experiment involving some kind of repeated action. Among them are the *Finger Ruler* drawings 1995 (fig.64) for which Orozco deliberately undertook the repetition of a childlike mistake by drawing along the edge of a ruler but allowing his finger that was holding the ruler in place to interfere with the straight line. The action is repeated over and over again in lines one beneath the other such that the resulting drawing looks like a map with small hills running through it, or perhaps something closer to a mechanical printout recording an apparently irregular heartbeat. The physical limits, tendencies, failures and idiosyncrasies of the body are frequently incorporated into Orozco's work in a manner that draws attention to the similarities and differences between the body and the machine. Orozco seems fascinated by the unconsciously performed action while remaining all the time attuned to the irregularities that will appear between one drawing and another, or one hand and another, despite

the attempt at repetition. The series of drawings *Havre-Caumartin* 1999 (figs.62–3) is a case in point. Orozco collaborated with a number of assistants to trace through rubbing, or frottage, the small tiles that line the interior of the Paris metro station whose name gives the series its title. Speaking of this series, Orozco has said:

When you do a frottage it's very physical – even if you do a rubbing of a coin or a leaf on a small piece of paper, it's a very physical thing. So I was thinking, what would happen if you do it big, so you have to really make a physical effort? I had been fascinated by these wall tiles since I was a kid – they look like big honeycombs, like constructions by bees, or something very organic. They were used in public spaces in the 1950s and 1960s and there are still some of them in Paris. I used large pieces of paper, the same type they use to rub the reliefs in tombs in Egypt – when you want to have a record of a ruined relief you use this paper. It's very thin but it's very resistant, so you can do quite nice frottage. I got a roll of this paper from the Musée du Louvre, and then there were four people with me, because also I wanted to see the differences in the way someone else did it. They are all very different depending on the action of the body and the personality of the person or when one gets tired at the end. The whole thing is the same texture, the same system, but every one is different, because of the body reacting in different ways.

Orozco has spoken of the indication within *Havre-Caumartin* of not only the physical tendencies and movement of the individual bodies as recorded by the drawings but also the impact of the space in which this took place. Often the station was very crowded and the movements of the frottage reflect the exertion of working around the busy station, and so the time of the piece is demarcated in the works not only through the individual behaviour of those executing the

drawings but also according to the activities in the station (rush hour, a train's arrival and so forth). There are similarities between this series and the later *Breathing Drawings* 2003 for which, with eyes closed, Orozco allowed a piece of charcoal to be guided around a piece of paper according to the exertion made by his breathing. The length of the line indicates the length and intensity of the breath and as academic and writer Briony Fer has stated, 'This is about as handmade *and* as mechanical, as concentrated *and* as distracted, as drawing can get. To make a work in the time frame of a few breaths is to make it in an instant. Yet to repeat the exercise will make a drawing that is completely different.'[16]

Once again these drawings elicit a parallel with Orozco's activities as a sculptor, where his actions are often circumscribed by the self-established rules of a game or exercise. The physical imprint and pressure applied in many of these drawings is an essential part of their making, just like the action of cutting, pressing or reconfiguring is in the three-dimensional work. The parallel is perhaps most apparent with a series titled *Dépliages* 2007, for which Orozco took the basic notion of the Rorschach inkblot test and complicated it by changing the folding of the paper. The results, made from oil paint on paper, have the bodily sensuality and physical intensity of his three-dimensional works from this time, such as *Pelvis* 2007 (fig.70) or the *Torso* series 2006 (fig.69), while Orozco uses the seeping paint from the tube to further extend the sexual analogies of the conjoining forms, created by the pressed paper acting more like an envelope, or a recipient – another constant subject in his sculptural work – and collecting the drop of paint inside. Made out of chance operations, intuitively and titled according to the city he was in and the date and time of their making, for example PARIS01082007160O 2007

(fig.67), they are a further illustration of Orozco's interest in the tension between the organic and mechanical, chance and control, accident and structure.

While individual drawings conceived for exhibition have increasingly become important in Orozco's oeuvre, it could be argued that another type of work on paper has always dominated his practice, that is, the artist's use of notebooks to document his ideas and experiment with planning projects and exhibitions. These notebooks developed as a systematic affair, each identical volume numbered and dated almost as an artwork might be. Asked about the origin of these books Orozco has said:

When I was travelling in Brazil I had small notebooks. Pocket notebooks. But then when I started to spend more and more time in New York, I started to concentrate a lot on writing and collaging in them, transcribing things I liked from the books I was reading. The notebooks became an important working space for me, much more important than just a pocketbook or a sketchbook.

Orozco has dated the increasing importance of these notebooks to the relative abandonment of his studio. He says:

In Mexico, I was working more and more in the street after I came back from Spain in 1987. And when I came here [New York] we lived in a very small place, and at the same table that we ate and cooked, I was working. And so I compacted everything into this notebook. And that's when the notebook became a bit bigger, and I decided to have just one size, and I numbered the first volume Number 1. And I now have seventeen notebooks, and they're carefully dated with all the locations and the year. It became a method, a real method of working, around 1991.

Orozco has found that he now returns to unrealised ideas documented in the notebooks, on occasion making the projects years hence. He says:

PARIS010820071600 2007 [67]
Oil on folded and unfolded paper
25 x 25

I have an idea in 1993 or 1994, for example, and I make it in 1999 or 2000. And I do think that the date of a work should be when the work is presented in public. The date of the work is when you show it, not when you conceive the idea or you work on it. It can be ten years of work before or one week before, but when you show it is the real date of when the work is born, when it starts to exist and to function, to be realised as art. On the other hand, I do not like archives very much and my notebooks are not a diary either. So, not all the photographs I have printed are archived in my notebooks, for instance. Not all the ideas are there either. And I have many pages of ideas that didn't work, but I did write about them, so they have their own life in those pages …

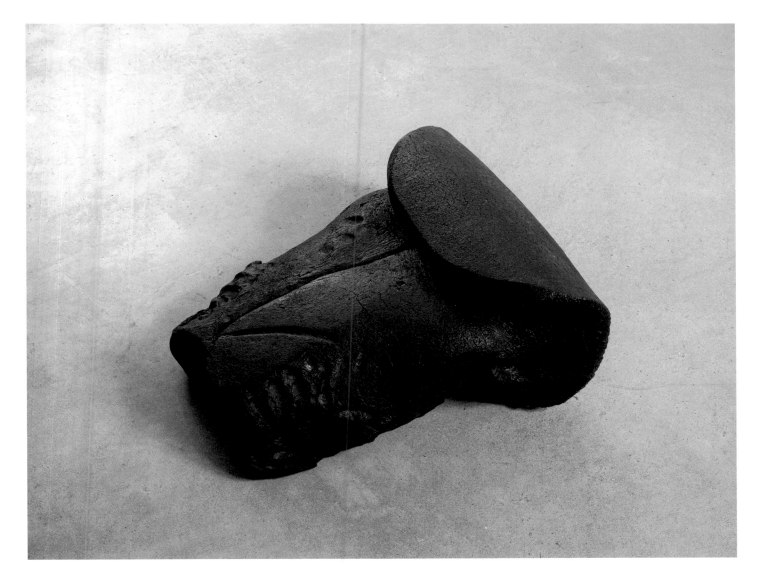

PELVIS 2007 [70]
Bronze
24.8 x 31.1 x 16.5
Edition of 7

DÉPLIAGE, WHITE 4 2007 [71]
Oil on canvas
66 x 66

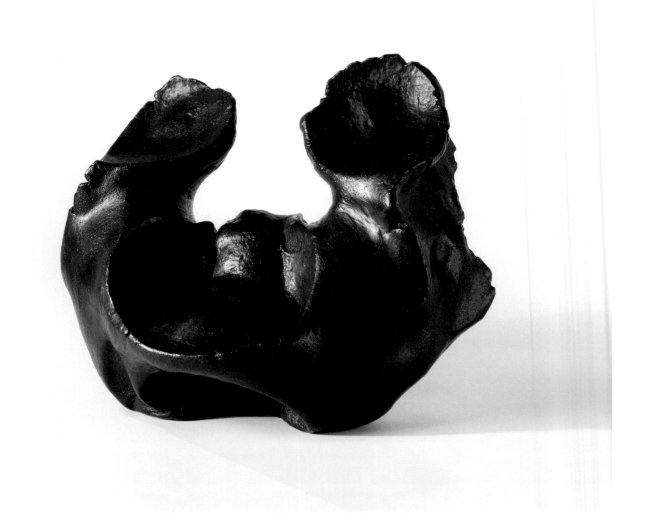

Made at the time of the Artangel commission *Empty Club* (fig.27), but shown only as large-scale prints on paper rather than as the preparatory collages, *Atomists* were a combination of newspaper images of sporting events (the name of the photographer and the caption in evidence) and Orozco's overpainting that was achieved through a pattern created on a computer and printed on top of the newspaper image. Orozco then painted in colour wash sections of the geometric forms in order to obscure part of the image below and create an intense surface disruption.

JESSICA MORGAN In the exhibition *Empty Club* you showed only the large-scale prints of *Atomists*, not the drawings. Why was that?

GABRIEL OROZCO Because the series was more like a graphic sculptural project. What I wanted to try to do was to blow up these images to life-size. To get this feeling of the body in movement, life-size. So they are clippings taken from the newspaper but blown up so you could see the grain of the image, but also you can feel the size of the body. And then on top of that is the geometric intervention. I did that very roughly with my portable computer. I was cutting out the sports photographs, the British ones are really amazing – the quality of photography, sports photography, is the best. And the way it's printed in the newspapers, and then how many newspapers are there in England? Unbelievable! So every day, I could get seven newspapers and work through the sports photographs and really enjoy looking at them. And at that point there were many things happening in sport, there was cricket, some athletics championships, and then Monsieur Eric Cantona playing at Manchester United …

So I was cutting these pages from the newspaper, and then I glued them to A4 pages. I had my own little printer with me and I'd print the diagram on top of the image. And then I did the colours on top. On the computer I had my collection of diagrams made before, based on this system of circles growing. They had their own rules, like sizes doubling or diminishing in half and the four colours placed in accordance with the knight's jumping movement in chess … Then we found a commercial printer to print them large.

JM Why are they titled *Atomists*?

GO The title *Atomists* came in reference to the Greek atomist philosophers, the ones who discovered, or better to say, conceived the idea of the atom – and who also conceived democracy. I was trying to think about how within the ball games and the photo printed dots and the molecules, all in different scales – micro and macro worlds – you have all this movement and transformation of molecules and matter and collision of forces and the motion of planets. Every sport represents the spatial culture that invented it – cricket or rugby is one conception of space and time, it is a social expression of a cultural landscape that is not the same as basketball or baseball, which are from a different time and a different perception of space. So *Atomists* are a way of considering sports and games as an expression of these theories of molecules, atoms, social order, social nature. Games are fascinating for me as ideas and conceptions of distribution and activation of space, and as a

Atherton takes evasive action from a Srinath bouncer during his unbeaten 53

Previous page
ATOMISTS: EVASIVE ACTION
1996 [72]
Ink jet print
199.7 x 95.3
Edition of 3

ATOMISTS: ASCENSION
1996 [73]
Ink jet print
196.9 x 69.8
Edition of 3

representation of our perception of landscape and
nature and how we order things, how we try to
structure nature and space, to urbanise it …

JM *Empty Club* was a project that centred on your
interest in games and gamesmanship. What is the
significance of this for you?

GO I think my work, every project I do, every different
material I use, is maybe in a way conceived as a
possible game. I rode the Schwalbe around the city
looking for another Schwalbe, it's a game. Or when
I take a car and cut it in two and put it together, in a
way it's also like playing with this car. So I think it's
not just games, but the beginning of starting to play
with things and trying to formulate a different way
of playing with something: a stone or a ring or
a branch. And when I try to disturb or to rearrange
readymade games, like chess with *Horses Running
Endlessly* (fig.26), or *Ping-Pond Table* (fig.29), these
are ways to reorient the perception of space in that
particular game, and of memories in relation with
that game. Billiards, for example, was a curious
case: I mean, I grew up playing carambole, a form of
billiards that has three balls, no pockets, and that's
the billiards I grew up playing and I have to say
that's the one I like. But when I conceived this
piece, *Carambole with Pendulum* (fig.28), and then
showed it in England I remember people being
puzzled not so much by the oval shape of the
table or because one of the balls was floating almost
miraculously above and beyond the green felt –
they were not so shocked by that. They were
shocked because it had no pockets! So it's
interesting how games are such an important part
of our identity, memory and cultural background.

ISLAND WITHIN AN ISLAND 1993 [74]
Silver dye bleach print
40.6 x 50.8
Edition of 5

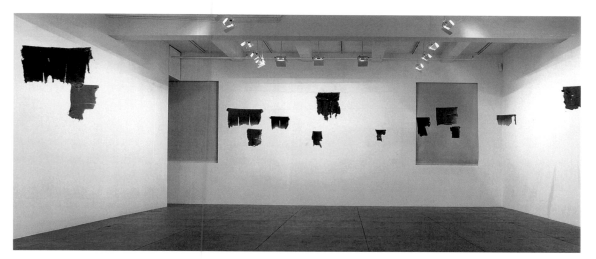

LINTELS 2001 [75]
Dryer lint
Dimensions variable
Installation view, Marian Goodman
Gallery, New York, 2001

MAKING / THINKING

In 2001, at the same time that Orozco exhibited *Fear Not*, his drawings from Costa Rica, at Marian Goodman Gallery (the title was also given to the exhibition), he installed a work (*Lintels* 2001, fig.75) that related both to the veined surface of the hands/leaves of the drawings and the fragile corporeality they brought to mind and to the recent events that had indelibly marked New York City on 11 September of that year (the exhibition opened in December). *Lintels* consists of an installation of sheets of lint suspended from wires in the manner of a sequence of washing lines. Extracted from a clothes drying machine, these thin, vaporous forms gave the impression of floating in mid air. The ragged edges of the sheets of lint and their grey colouring uncannily resembled the ruined Twin Towers (buildings that featured in what has become one of Orozco's better known photographs, *Island within an Island* 1993 (fig.74), despite the fact that he had conceived of the piece before the attacks on the World Trade Center). The lint sheets on closer inspection revealed their true substance: hair, nails, clothing fluff and, of course, dust. Dust is a material that had long been of importance to Orozco and that immediately suggested a relationship to Duchamp's work, whose fascination with dust was a result of witnessing its accumulation on the surface of the *Large Glass* 1915–23, an effect that he then permanently created within the sculpture. Orozco's interest in dust – as evidenced in *Yielding Stone* (fig.10) and other works – is related to a combination of factors, including the 1985 Mexico City earthquake, which killed 10,000 people and destroyed large parts of the city. Of course the memory of the ruined city was recalled by the situation in New York post-11 September (although the artist was actually living in Costa Rica when the attacks took place). The explicit corporeality of *Lintels* – which literally contains the human body in its elements – cannot help but be read as an elegy of sorts, if not to the victims of the attacks, at least with the benefit of hindsight to the end of a moment in which the West's population (naively?) considered itself immune to major conflict.

The first body of sculptural work that Orozco made after his *Fear Not* show took many by surprise. In much the same way that *Yogurt Caps* (fig.20) or *Black Kites* (fig.37) had perhaps defied expectations, Orozco's venture into terracotta, first seen in *Cazuelas (Beginnings)* 2002 (fig.85) shown at *Documenta XI*, seemed a peculiarly traditional direction for the artist to be taking. Orozco's interest in the pot shape had been a motive for his research trip to Mali, where he unexpectedly encountered funereal vessels marking graves at the outskirts of Timbuktu (which he had documented in the series of photographic works titled *Cemetery*, figs.1, 52). But for his own pottery project, Orozco searched for a place where he could find the type of clay used to make bricks and which Orozco had employed when he had made *My Hands Are My Heart* in Mexico (figs.7–8). Eventually finding a suitable place in Burgundy (France), in a converted ceramic workshop that had once been a traditional factory for tiles and bricks in the region, Orozco spent one week with the workshop master creating a series of pots on the wheel, later titled *Cazuelas* (Mexcian slang for pots). A typically Orozco-like game-based process was used: in this case asking the potter to go about the initial stages of turning a vessel on the wheel at the same time as Orozco was interrupting the orbit of the rotation of the pot by throwing different sized clay balls from various distances onto the turning wheel. The end result is a series of corrupted bowls, thick and ungainly with balls of clay smashed into the sides, in some cases totally collapsing the vessel. There are seventy-one bowls in the complete installation,

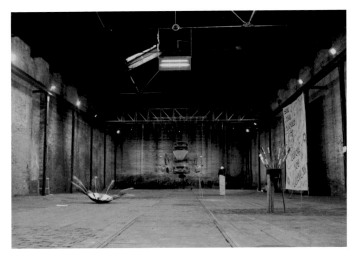

EVERYDAY ALTERED [76]
Installation view, Venice Biennale,
2003
Courtesy kurimanzutto,
Mexico City

SHADE BETWEEN RINGS OF AIR
2003 [77]
Wood and metal
280 x 800 x 1,400
Installation view, 50th International
Art Exhibition: Dreams and
Conflicts – The Dictatorship of the
Viewer, Venice Biennale, 2003

SHADE BETWEEN RINGS OF AIR
2003 [78]
Installation view showing
Carlo Scarpa's 1952 pavilion

which in totality suggests the different stages of organic growth or development from origin to decay.

Cazuelas transpired to be just the beginning of an ongoing process of working in Burgundy with this pottery. Orozco, who now has a home nearby and spends time there every summer, has produced numerous bodies of work using the mortar la cotta, initially following *Cazuelas* with a group of objects that referred in their form to the process of working with this material, which requires an extended period of drying before being wood-fired – like the traditional tiles – and a process analogous to that of the fermentation of dough when making bread. The works in this new series, shown at Galerie Chantal Crousel, Paris in 2003, were placed on market tables, not dissimilar to those that Orozco had photographed in *Crazy Tourist* (fig.46), further emphasising their connection to a foodstuff cooked and presented for consumption. The objects were made in an entirely different manner to *Cazuelas*, however. Elongated and rounded loaf-like shapes with flattened and circumscribed ends (created from the pressure of a wooden ball), the clay sculptures were created in proximity to the artist's body rather than in dialogue with the wheel of the potter. Orozco held, carried and moulded the clay in a manner that recalls *My Hands are My Heart* but crucially does not consist of a cast of his physical presence but rather an extended or phantom limb, or perhaps the physical sensation made abstractly three-dimensional of holding a baby or a body part or some organic, weighty natural product, as demonstrated by the singular piece *Double Tail* 2002 (fig.86).

Invited again by Francesco Bonami to participate in the Venice Biennale in 2003, Orozco had the opportunity to intervene both as an artist and as an artist-curator. His curatorial venture brought together many of the artists that had participated in his informal workshop in Mexico City more than a decade before, including Abraham Cruzvillegas, Damián Ortega and Daniel Guzmán (b.1964), as well as artists with whom he had developed an association over the past years such as Jimmie Durham and Jean-Luc Moulène (b.1955). In his memorable section, titled *Everyday Altered* (fig.76), in an altogether remarkable Biennale – the nearly dozen curators invited by Bonami creating a radical cacophony of curatorial approaches in the Arsenale – Orozco's floor plan bore some resemblance to the manner in which he typically installs his own work, creating an open-plan field of reverberating associations, from the kinetically charged spinning oil barrels of Damián Ortega's *False Movement (Stability and Economic Growth)* 1999 to the interruptive gesture of Fernando Ortega's electric fly killer that, once hit by an unsuspecting insect, would cause a power cut in the dramatically cavernous space. Alongside his curatorial venture, Orozco presented in the Italian Pavilion his own new work, *Shade Between Rings of Air* 2003, a replica of architect Carlo Scarpa's (1906–1978) pavilion for the 1952 Venice Biennale (figs.77–8). Originally created in order to form a sculpture courtyard, Scarpa's pavilion had languished ever since, experiencing a process of dampening and decay, foliage partially hiding the concrete structure. *Shade Between Rings of Air* was situated immediately adjacent to the Scarpa piece, and consisted of a one-to-one scale wooden replica that seemed to mirror the outdoor eroded concrete original. Orozco's work was located in a gallery whose whiteness and open doors made immediately apparent the twin presence of the linear form but also the sharp contrast between the ancient 'naturally' damaged construction and its parallel ideal model built to scale. Although the work seemed entirely site-specific in Venice, it was later shown in the Palacio de Cristal in

Installation view, Museo Nacional
Centro de Arte Reina Sofía, Palacio
de Cristal, Madrid, 2005

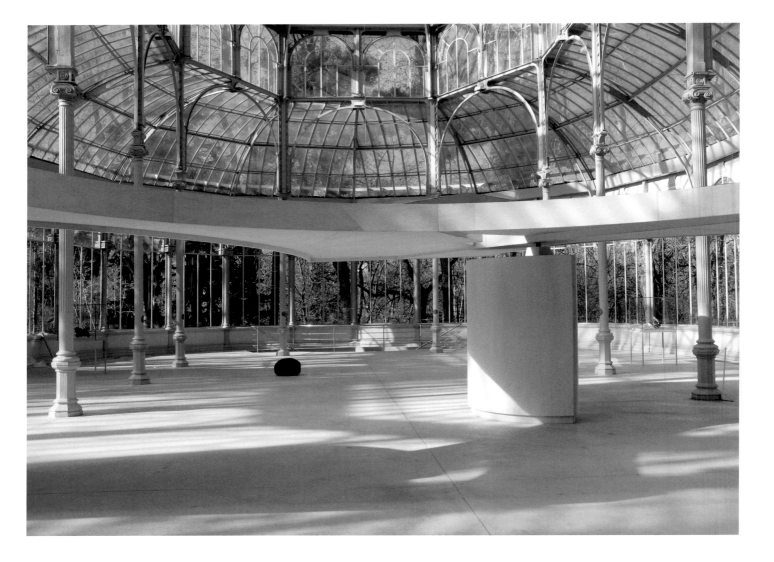

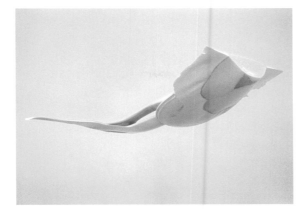

SPUME STREAM 2003 [80]
Polyurethane foam
25.4 x 172.7 x 104.1

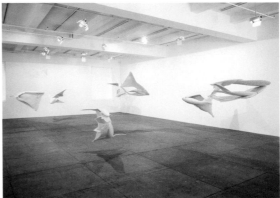

SPUMES 2003 [81]
Installation view, Marian Goodman
Gallery, New York, 2003

Madrid as a freestanding sculpture minus its neighbour referent (fig.79). The vast, luminous space of the Madrid venue was in fact an ideal situation for *Shade Between Rings of Air*, its elegant white curvilinear ceiling creating a respite from the otherwise exposed space of the glass and steel structure. Seen separately from the original Scarpa construction and as a sculpture dwarfed in a much larger space than in Venice, it was possible to identify more clearly the manner in which the structure replicates the linear, curved shapes of Orozco's oeuvre – in fact suggesting a thin slab out of which two circles had been cut. Like so many of Orozco's appropriations, it was fluidly absorbed into the artist's vernacular, becoming a sculptural drawing in space.

Orozco's next major body of work recalled the elegantly suspended roof of *Shade Between Rings of Air*. *Spumes* 2003 (figs.80–1) was an experiment with a new material to which Orozco had been attracted: polyurethane foam, a material commonly used in construction as a filler between materials. Speaking of this toxic substance, Orozco has said:

What I was interested in was having my own experience with a common construction material that I found very attractive and quite repulsive at the same time. It's super-artificial and toxic, but at the same time organic and somehow it behaves in the way the universe works. As a hot liquid, producing bubbles in expansion ... until it dries out in a few seconds ... Is interesting how many things are made out of this, like surfboards ... It has been around in my perception for a long time, but I didn't know what to do with it until then.

Orozco allowed the polyurethane to expand unheeded (the foam triples or even quadruples in size), placed in acrylic recipients or 'hammocks' made from latex to control the flow of the foam the expansion and hardening of which is fast-paced,

requiring decisive direction. The results resemble wings, bones, fish, petals or even industrially-produced objects such as surfboards, organic-looking shapes that Orozco suspended in the air for his exhibition at Marian Goodman Gallery in 2003. The doughy yellow colour of the foam gave the impression that the *Spumes* might be prototypes, in a preliminary state awaiting further delineation and colouring (an eventuality that would result in the loss of their slightly unfathomable and utterly appealing abstraction). Their mobile position drew comparison with the suspended structures of Rodchenko, whose geometric shapes similarly required the movement of the viewer in space to subtly cause the air around the pieces and thus the works themselves to move slightly, further enhancing the impression of flight. The *Spumes* are consistent with much of Orozco's thinking in that they bring together the game-based decision-making that provides endless stimulation for the origins of most of his projects – a creatively playful beginning that is undergirded by serious reflection – while at the same time requiring a careful, learned precision in the physical making of the sculpture and the handling of the material or process.

While *Spumes* may represent the more organic aspect that typifies one feature of Orozco's practice, there is always the concomitant presence of something more analytical in the production or final associations of the work. Speaking about these two forces Orozco has said, 'on the one side are the ceramics and the *Spumes,* which both have a very loose organic liquidity. And then on the other hand there is work like *La DS* (fig.25), which is more geometrical, more about structure and machine. I think I am always collapsing the two of them.'

From the bone-like forms of the *Spumes* Orozco moved on to the real bones that he collected of a grey whale in the commissioned *Matrix Movil* 2004, made

in time for the opening of the National Library in Mexico City. Working with Marco Barrera Bassols, the former director of the Natural History Museum in Mexico City, Orozco went to the Isla Arena on the Baja coast of Mexico to find an appropriate skeleton for the piece. Perhaps relating the magnitude, literary associations and mythic symbolism of the whale with the content of the library, Orozco decided to transform the skeleton into an enormous drawing. Extending the potential of *Black Kites* (fig.37), he worked in graphite with the assistance of others to map the reverse contours of the whale skeleton. While the bones of the whale already suggested a drawing in space, Orozco further enhanced this impression with the graphite markings creating an alternative geometry on the surface.

For this piece and others, Orozco has always emphasised the importance of the process of making. The decisions behind whether to draw or cut, press or assemble have consistently informed the meaning and import of his oeuvre and this is no less the case with a monumental piece such as *Matrix Movil*. Some aspects of the work may be planned but the process of making leads to an understanding of the significance of the decision or gesture. Speaking of his method of production Orozco has said:

For me, what is important is the making of the work, how you make the work is fundamental for the final result. It's not just that you have the idea and then you, or somebody else, makes it: they go together. You are making and then you have an idea. You have the idea and then, when you are making, you have another idea, sometimes out of an accident in the process. I think to have really original ideas, if they exist, or personal ideas, you have to be constantly concentrated in the making and in the small decisions and the way you decide how to work each idea. How you make things is going to influence the type of work you are going to do. It's totally integrated. If it gets

disintegrated or alienated, the making and the thinking kill each other ...

In light of this statement, it was a great surprise to followers of Orozco's work when he first exhibited a group of paintings as part of a solo exhibition at the Serpentine Gallery, London in 2004. Orozco designed the paintings using a systematic structure based on radiating, bifurcated circles and a colour scheme that followed the moves of the knight in a chess game. Orozco's long-time Paris-based assistant, Philippe Piccoli, was taught by Orozco to achieve the quality that he desired for future painting series. The *Samurai's Tree* series (figs.82–3) and other similar painting works in fact resembled previous projects of Orozco's – including notably the *Atomists* series (figs.72–3) and also the banknote and airline tickets drawings (figs.58, 60) – but the substantive shift was the use of paint on canvas and in some cases the more archaic mode of gesso on panel. Orozco has always maintained that the paintings are closer to objects: there is a machine-like derivation in the constant reproduction of the *Samurai Tree Invariants* 2006 (fig.84) – in which every possible colour permutation (permitted by the established set of rules) within the same compositional structure is established on a computer and then realised slowly as paintings, one by one, but also as a chart, a set of 677 prints, and as a video animation showing one image per second. But ultimately the work consists in the slowly advancing gold and tempera painted form, which is as mechanical as auratic in the presence of painterly touch. The artist has described them as 'platforms for action' but their visual manifestation is prescribed in a manner similar to artist and founder of De Stijl Theo van Doesburg's (1883–1931) notion of programmed art, in which all decisions have been mathematically established beforehand and can be computed by the viewer.

SAMURAI'S TREE 1M 2004 [82]
Egg tempura on red cedar panels
with gold leaf
55 × 55

SAMURAI'S TREE 2N 2006 [83]
Egg tempura on red cedar panels
with gold leaf
55 × 55

Despite their clear relationship to earlier series such as *Atomists* and Orozco's incursions on the surface of banknotes and airline tickets, the key difference is that in *Samurai Tree Invariants* the geometric forms do not act to interrupt the information below but rather exist entirely independently. They appear to be abstract works in and of themselves. So what kind of paintings are they? Yve-Alain Bois has made the point that Orozco has approached this new medium in much the same way that he has done others: by treating the entire available history of art as an open playing ground. Just as his sculptural works, and in particular the terracotta sculptures, reference both ancient and contemporary (with many stops in between), western and non-western traditions, similarly, as Bois has said, there is a 'telescoping of time in that counterintuitive graft of a Quattrocento practice onto that of a Mondrian' in Orozco's paintings, but this 'oblique point of view is perhaps the only way to rekindle [painting's] flame'.[17] Orozco's paintings, once the surprise of encountering paint or gesso on canvas or wood in the work of an artist most commonly associated with found objects and photographic form has been overcome, are in all other aspects a logical continuation of his practice – indeed even these painterly materials have an organic origin. From games to geometry and from atomic compositions to the all-over pattern that literally consumes the surface of the painting, Orozco's familiar tropes are all at play.

JESSICA MORGAN Was *Cazuelas* the first time that you had worked with ceramics?

GABRIEL OROZCO The first time I worked with clay was in Cholula in Mexico, when I did *My Hands Are My Heart*. And I didn't do anything else after that, I was not interested in ceramics or clay that much. But then I had this idea of the *Cazuelas* for *Documenta*, in 2002. A lot of my work has to do with the container or the recipient, emptiness, circularity and motion. I thought at that point it would be fun and interesting to work together with somebody who knows how to use a wheel making pottery, and then I could intervene during the process. So I could kind of distort the making of something very mechanical.

JM What was your relationship with the people who were producing the ceramics?

GO I found a workshop that was used to working with artists, a ceramicist that knew traditional ceramics as much as contemporary. But also it was very important that the clay was a specific type of clay, more like terracotta, that was used for brick making. Because you can get more thickness in the mass – with traditional fine ceramics clay has to be very thin and very dense, so you cannot let it get too thick because it breaks in the firing. So it was a very specific type of workshop I needed. An old-fashioned brick factory.

I wanted to create an accident in the mechanical process. So in this case, when the ceramicist was using the wheel, making different shapes that I asked for, I was at the same time throwing clay balls at them to disturb the orbit of the rotating soft pot. Also I was adding small clay discs to the fresh pots and also making pots out of those discs. It was a nice experience, I liked spending time there. So I came back a year later with another idea, which was more related to the making of bread, or fruit shapes or body configurations. After this experience it started to be an ongoing activity. I got hooked on it, a little bit like it happened with photography.

JM What was the significance of the pot form? Were you thinking about its relationship to ancient art?

GO It's just such a basic form and a basic instrumental part of human history. I was curious to play with this instrument. The bowl, the pot, the plate, those things that are so basic for conservation, transportation and production of all things. I went to Mali and I discovered by accident – I didn't know it existed – this cemetery in the desert sand with pots as grave-marks. I took some photos of them. I have to say that before, in museums, when going through the rooms of ceramics and pottery, I normally would walk really fast and try to leave immediately. I was bored to death seeing pottery and ceramics. But now I have much more respect, it's amazing how wonderful a technique ceramics is in general. How difficult it is, how challenging it is …

JM You never considered making a cast of these objects?

GO I don't like moulds, I hardly ever use moulds in my work. The idea of making a recipient to make a sculptural reproduction, or a material exact representation … that's exactly what I don't like about conventional sculpture … You make a mould and then you have a three-dimensional

trompe l'oeil. It's like the Brancusi/Rodin dilemma. Rodin modelling by hand in clay and then using moulds to reproduce his figures in bronze. I guess there is a moment when you have to take sides … and then either you're on the reproduction side and you make a lot of them like Rodin, or you are more on the Brancusi side, which means that somehow every piece is unique even if it is mechanically remade, and if you do similar things, or variations, they are for a different sculptural reason each time.

Overleaf
CAZUELAS (BEGINNINGS)
2002 [85]
Fired clay
Dimensions variable

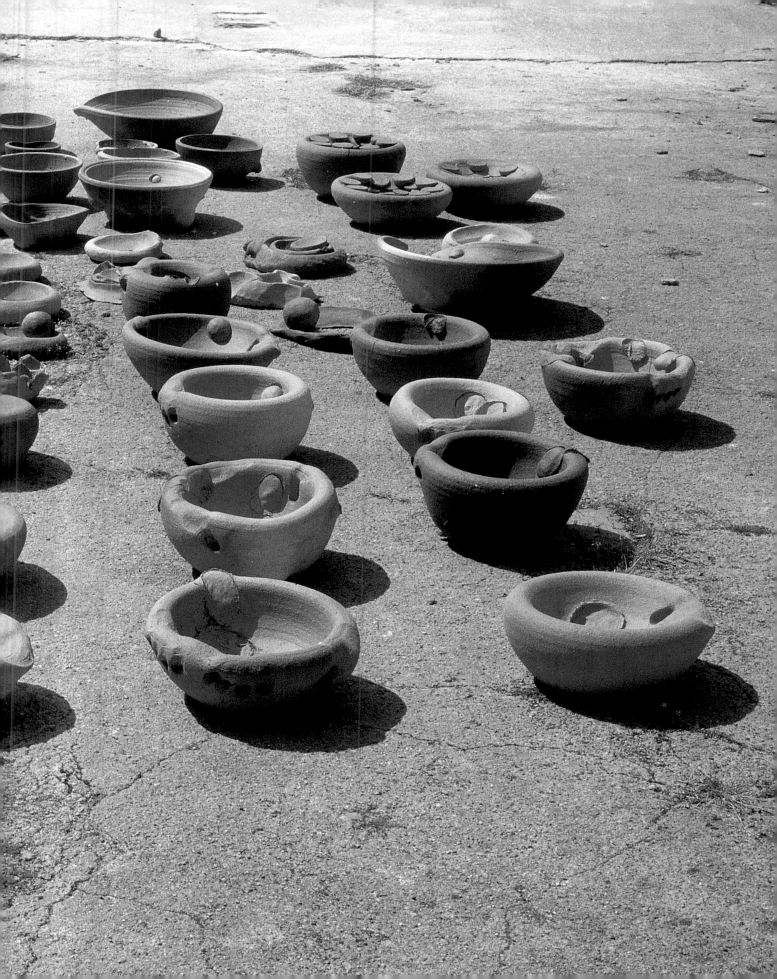

I want to open up ... space as a recipient for the spectator to occupy. I want to erase my presence ...When you impose yourself as the performative aspect of the work that is not only expressing the narcissistic but also something tyrannical.

Despite Orozco's insistence on the erasure of his presence, I would argue that his entire oeuvre is indelibly marked by the suggestion of his absent presence. It is an active absence of which we are constantly aware in his work: whether considering the origin of the humid circle of breath on the surface of a black lacquer piano top; the action of rolling a giant ball of plasticine through the streets of New York; the imprint of the body that cradled a lump of clay; or the humorous mindset that came up with the idea to playfully place food on the streets of Tokyo. For all Orozco's stated desire to withdraw physically from the residue of his actions, he is unmistakably foregrounded in his art in a manner that remains elusively compelling. The quotation above refers to the fact that Orozco himself is never physically present in any of his pieces. We do not see the artist 'in action' in his photographs (with the peculiarly symbolic exception of the diptych *My Hands Are My Heart*, fig.8) and, although we are constantly aware of his physical manipulation of materials and the relationship to his body (including its specific measurements and weight), we never see this figure represented. As discussed below, however, Orozco references a form of performance or action-based art in his own production although carefully avoiding, through his physical absence, any direct comparison with the body or performance art linked directly to the body of the artist. Nevertheless, his use of certain tropes elicits comparison with artists such as Ana Mendieta (1948–1985), whose drawings on leaves, body impressions and sculptures formed around her body clearly relate to Orozco's practice. The fundamental difference is that Mendieta included her own presence in recordings of her performance work and in her photographic studies.

The appeal of Orozco's absent presence is multifaceted and plays out in his production in a variety of ways according to the chosen media. Examining first his photographic work where the documented actions and observations were undertaken by an individual who remains elusively beyond the frame, Orozco's absence inevitably leads us to wonder about the person who was capable of finding such affecting and resonant moments – who is this invisible actor or instigator? Simultaneously, his absence allows us the privilege of imagining our own possible involvement in the act of creation: two of the most powerfully compelling aspects of Orozco's art are its humility and simplicity, which allow us to connect immediately with the act of its making and which lay bare the process of its creation such that we can retrace the steps, occupying them, imaginatively, ourselves. Many of his actions remain close in spirit to the casual doodle on a notepad or the kind of activity undertaken without premeditated thought. We intuitively understand and feel drawn to the history of these objects and their making. Orozco's photographs record the kind of small miracles that we observe in the world around us – a puddle's reflection of light, animal behaviour, the geometry of nature – the same occasions that may have fleetingly caught our own attention. As a result we are lulled into thinking that these captured moments were shared in some sense and that we occupy a common ground. As Orozco states, he creates 'space as a recipient for the spectator to occupy' but I would argue that this is an active role whereby we

retrace the movement and gestures, the 'performance' of making his work.

Of course the reality of these apparently simple gestures is quite different from our perception of them, and the illusion that we can replicate them with ease is largely that – an illusion. Fisher has described her surprise when enlisted by Orozco on the beach in Mexico to realise a temporary project that he was making. Asked to help produce the small balls of slightly damp sand that he was placing in the crevices of a rock face bordering the beach, Fisher discovered, despite their apparent simplicity, that skill and judgement were required in getting the right amount of sand and water to create a 'good' ball. Most important though was the sensual aspect of this procedure, the realisation that the best ball of sand is made in relation to one's own body. She writes, 'One could say, therefore, that the "most perfect" sand ball, is an index of the interior space of my cupped hands, and thus becomes their extension into the world, just as we, in making the balls, are the extension of the artist's hands.'[1] As with so many of Orozco's sculptures we are once again made aware of the physical presence of the artist in producing the work, which itself is a trace of his action and his body. We may perhaps project that his hands or breath could be replaced with our own, but nevertheless the arresting quality of the piece is the knowledge that it was – perhaps only recently – physically produced by the action of the artist. Fisher's story recalls the making of *My Hands Are My Heart*, the compressed clay object made while Orozco was assisting Gormley on his mammoth project, *American Field*. While Gormley's *American Field* is the result of a labour-intensive group activity, Orozco's is the directly personal gesture of the artist, in this case linked irrevocably to his body through the unusual documentation of the artist 'enacting' the making of the sculpture in the photographic diptych of the same title.

Many of Orozco's sculptures and works on paper perform a similar gesture of applying physical pressure to a material, whether it is the action of pushing *Yielding Stone* (fig.10) through the streets of New York or the process of cradling, rolling or compressing that created the terracotta works *Double Tail* (fig.86) and *Four and Two Fingers* 2002 (fig.87), all of which have an indexical relationship to the artist's body. There is, moreover, a sensual pleasure in savouring the physical hand of the artist in Orozco's work, which places much weight on the satisfaction of experiencing the dexterity and unique touch evidenced by the 'auratic' artwork. The authenticity implied by Orozco's evidently handmade pieces simultaneously fuels the interest in his absent presence, the author's physicality being so heavily inscribed in the surface of the sculpture. Even when investigating the potential correlation between man and machine in the repeated gestures he has explored in his drawings, it is Orozco himself undergoing the experience of the repeated gesture rather than employing studio assistants to perform this task. The mental and physical process appears to be very much part of the process and although we may never see the artist in action it is impossible to observe the work without being aware his participation, especially when it consists of a series that is shown in some depth to give an impression of the activity involved.

It is not only the physical impression of Orozco's hand that leads to a performative reading of his sculpture however. Works, whether fabricated or made from altered industrial materials, are suggestive of a relational form of performance that calls on the viewer's participation but that also relates to the bodily interaction of the artist. Both *Elevator* and *La DS*, for example, have been constructed to function in accordance with the human body and both were originally designed to be entered by the viewer. The former is a lift cabin that has been reduced in height to

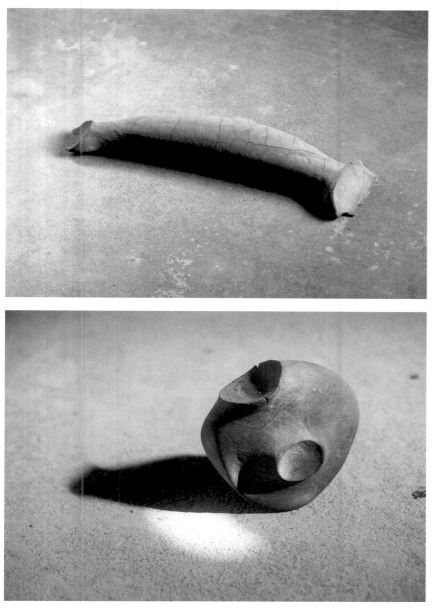

DOUBLE TAIL 2002 [86]
Fired clay 13 x 70.5 x 20.9

FOUR AND TWO FINGERS 2002 [87]
Clay 13 x 39 x 19

the artist's frame and the latter is a classic French car that has been reduced by a third of its width. Both alterations create spaces conceived to bring about a physical sensation. They are sculptures that become containers for the body thereby conveying a sense of movement: the reduced height lift replicates the peculiar sensation of rising in space but remaining static, and *La DS*'s streamlined body conveys the speed of a race car.

Orozco's game-based works from the mid-1990s involve a type of relational choreography that the artist has dictated through the altered design of a traditional form. *Ping-Pond Table* (fig.29), for example, establishes a challenging new game of ping-pong that requires the dextrous avoidance of a lily pad-occupied pond at the centre of the table, which itself has been doubled to allow for a four-sided match (the corners thoughtfully rounded to avoid the typical bruising caused by a hip brushing against the edge). A cartoon from *The New Yorker* (11 January 1999, fig.88) gives some impression of the physical skills and movement required to play the game and Orozco himself has expressed an interested in the imaginative (if not actualised) motion of the ball arcing from table top to table top kinetically creating a drawing in space of a section of a circle, the leitmotif of his work, here performed by the planet-like ping-pong ball. Other deliberately choreographed sculptures include *Carambole with Pendulum* (fig.28), in which the suspended red billiard ball, when hit by the viewer/player, moves in an unpredictable arc through the exhibition space, once again recalling interplanetary movement but also, through the physical activity of the player trying to hit the now moving ball, a type of Cageian controlled randomness visually held in place by the centrifugal force of the oval baize centrepiece around which the action moves.

Orozco is a great sports player, whether football, ping-pong or the more cerebral game of chess, and

clearly his experience and pleasure in movement through sports and games are explored physically in the sculptures and projects from the mid-1990s where Orozco replaces or adds to his own movement with the potential participation of the viewer. Similarly choreographic, and pointing to the importance of projected or imagined movement in his work as much as the physical sensation itself, are *Until You Find Another Yellow Schwalbe* (fig.53) and *Horses Running Endlessly* (fig.26) – the former establishing a game based on the map of Berlin and the latter revolving around the idiosyncratic movements of the knight in chess. Although the artist's interaction remains out of sight, we have an intuitive sense of his own participation and our position occupying his recently vacated seat, so to speak.

Like the sculptures impressed and marked by the artist's weight, many of Orozco's drawings retain or revolve around the physical pressure of Orozco's body, suggesting that the finished drawings are in some sense the residue of a performative act. The series *Havre-Caumartin* (figs.62–3), for which Orozco, aided by a group of assistants, made a frottage of the tiles in the Paris metro station that provides the title for this work, is emblematic of this trope. Pointless as individual drawings, they must be seen in groups in order to gain a sense of the differently performed exercise, as Orozco says 'They are all very different depending on the action of the body and the personality of the person'. Although not comparable to photographs documenting a performance, there is a close resemblance to the thinking of Cage again and in particular to his collaborative gesture with Robert Rauschenberg (1925–2008), *Automobile Tire Print* 1951, for which the artists laid out a long scroll of paper in the street that was then driven over by the inked tyre of a truck. The drawings by Orozco that are the result of physical pressure or the limits and capacities of the body most strongly recall the sculpture and drawings of Giuseppe Penone (b.1947), whose use of frottage on natural materials such as wood and leaves similarly calls for a correlation between the organic growth of vegetal life and the surface of the human skin. Penone's work foregrounds the 'absent presence' that we encounter with Orozco, as he so frequently uses his own body to create or delineate a piece. Whether it is the equation of the lines and surface of his skin with the rings of a tree or the veins in a leaf (a trope that appears similarly in Orozco's *Fear Not* (fig.56) wherein the lines of the palm and the lines of the leaves are traced in such a way as to recall palm reading or information charts), or the variable use of pressure on a surface to indicate the physical action and interaction required in frottage, or indeed the use of the scale of his body to define a sculpture's limits, Penone's work draws on the indexical quality of drawing.

Referring less to the imprint of an indexical relationship to his body, Orozco has also made numerous works that incorporate time to convey the physical or performance-like aspect of their making. *Breathing Drawings*, for example, is the result of a breath's physical effect on the body and in particular in this case the movement of the hand holding a piece of charcoal. The *Dépliages* series (fig.71), although the result of the artist's manipulation and pressure of paint on a folded piece of paper, are also time-based works in so far as the artist has employed materials with a long and evolving process of drying as the oil paint gradually seeps into the paper support. Orozco chose to title them according to the place, date and time in which they were made, suggesting that this information is in some way relevant to the final outcome and that once again an almost mechanical process lies behind the relentless production. Orozco draws our attention specifically to the brief gesture of making the drawings and its relative efficiency or

alteration over time as evidenced in the changes that take place in this large series. Orozco, as is so often the case, has set himself a task to be learned or a game to be mastered or experimented with, his body becoming a tool that gradually gains skill but also falls prey to certain patterns or idiosyncrasies reflected in the repetitive act.

To return to the question of the role of performer in this process we need also to address how Orozco's residual presence is different from, for example, the evidence of touch and brushstroke in a painting, a history of mark making that similarly denotes the physical actions of its maker. What relates Orozco's unseen actions to performance any more than the studio practice of a painter whose habitual gestures and movements have in some cases famously been recorded precisely for their choreographic, performative qualities? The most pertinent difference would appear to be the fact that Orozco undertakes his actions not in the privacy of the studio but rather in the public realm. Of course there is no audience as such. Orozco works alone making and documenting his art for his own entertainment, so to speak. But the fact that these actions take place in our shared domain – the street, park, restaurant or museum – suggests that we may have inadvertently witnessed the action or a temporary sculpture's making and its presence in a public space is an intentional aspect of the piece. This is not the private development of a personal language that can be gradually unpacked or decoded – as we observe in most painters' oeuvre – rather this is the purposeful use of a shared vocabulary of the 'everyday altered' (to use Orozco's own Venice Biennale 2003 exhibition title) and we can easily access its origin even if we cannot in fact replicate it. Orozco uses the urban scape as well as the landscape terrain as his stage and it is a platform that we share.

The street has a long history of being occupied by performance work and as with so many other aspects of Orozco's activities we can read into his own actions in the public realm a recent history of references that may have affected his thinking. The influence of Cage once again is primary, a fact that Orozco acknowledges from his early days when making slight arrangements of found materials in the parks and streets of Madrid. The concepts that underpinned Cage's 'experimental composition' classes taught at The New School in New York that influenced the 'happenings' and Fluxus work of Allan Kaprow (1927–2006), George Brecht (1926–2008) and others could also be seen to inform the ideas that Orozco began to explore in his unscripted outdoor actions where chance was a key determinant in the initial outcome creating an openness for encounter (albeit one often followed by a system of control and structure in counter balance). The *Penske Work Project* (figs.33–5), for which Orozco undertook to identify debris on the streets of New York and make on-the-spot sculptural assemblages from the available materials, illustrates this aspect of his practice, whereby a chance encounter then develops into an action that follows the 'rules' prescribed by the artist. Ultimately transported to Marian Goodman Gallery for display in the clean and controlled environment of the uptown location, the title of the work indicates the temporary storage and transportation for these seemingly ephemeral sculptures and adds further to the aura of action and event around the making of the installation.

Orozco's itinerancy, his work in various locations and found situations, and his inquisitive desire to transform the space in which he finds himself, have resulted in a body of work that is not so much a biographical trace through time, but rather a physical and sensual presence that we have been able to track and sympathetically experience; following in his footsteps after projecting onto his imprint or imagining our own occupation or transformation of the spaces and objects that he has created.

New Yorker cartoon of ping pond table
11 January 1999 [88]
Marcellus Hall, originally published in *The New Yorker*

Notes

1 All quotations, unless indicated otherwise, are from the author's conversations with the artist that took place in New York in November 2009 and January 2010.

2 Benjamin H.D. Buchloh, 'Interview with Gabriel Orozco', in Hans Ulrich Obrist (ed.), *Gabriel Orozco: Clinton is Innocent*, exh. cat., Musée d'Art moderne de la Ville de Paris, Paris 1998, pp.85–7.

3 Benjamin H.D. Buchloh, 'Sculpture Between Nation-State and Global Commodity Production', in Ann Temkin (ed.), *Gabriel Orozco*, Tate Publishing, London 2009, p.42.

4 Gabriel Orozco in conversation with Benjamin H.D. Buchloh (2004), in Yve-Alain Bois (ed.), *Gabriel Orozco* (October Files), MIT Press, Cambridge 2009, p.106.

5 Francesco Bonami, 'Now We Begin', in Frances Morris and Richard Flood (eds), *Zero to Infinity: Arte Povera 1962–1972*, exh. cat., Walker Art Center, Minneapolis 2001, p.123.

6 Benjamin H.D. Buchloh, 'Cosmic Reification: Gabriel Orozco's Photographs', in Rochelle Steiner (ed.), Gabriel Orozco, exh. cat., Serpentine Gallery, London 2004, p.78.

7 Miwon Kwon, 'The Fullness of Empty Containers', Frieze, no.24, September–October 1995, p.54.

8 Gabriel Orozco, 'Portable Puddle', in Ann Temkin (ed.), Gabriel Orozco, exh. cat., MoMA, New York 2009, p.101.

9 Guy Brett, 'The Light Touch', in James Lingwood (ed.), Empty Club: Gabriel Orozco, exh. cat., Artangel, London 1998, p.106.

10 Benjamin H.D. Buchloh, 'Cosmic Reification: Gabriel Orozco's Photographs', in Rochelle Steiner (ed.), *Gabriel Orozco*, exh. cat., Serpentine Gallery, London 2004, p.78.

11 Nicolas Bourriaud, *Relational Aesthetics*, Presses du reel, Paris 2002, p.17.

12 Guy Brett, 'The Light Touch', in James Lingwood (ed.), *Empty Club: Gabriel Orozco*, exh. cat., Artangel, London 1998, p.100.

13 Benjamin H.D. Buchloh, 'Cosmic Reification: Gabriel Orozco's Photographs', in Rochelle Steiner (ed.), *Gabriel Orozco*, exh. cat., Serpentine Gallery, London 2004, p.78.

14 Ibid., p.82.

15 Daniel Buren, 'The Function of the Studio', *October*, Fall 1979 (originally in French, 1971; trans. Thomas Repensk).

16 Briony Fer, 'Spirograph: The Circular Ruins of Drawing', in Rochelle Steiner (ed.), *Gabriel Orozco*, exh. cat., Serpentine Gallery, London 2004, p.16.

17 Jean Fisher, 'The Sleep of Wakefulness', in *Gabriel Orozco*, exh. cat., The Kanaal Art Foundation, Kortijk 1993, p.15.

Biography

| 1962 | Born in Jalapa, Veracruz, Mexico |

Education
| 1981–4 | Escuela Nacional de Arte Plasticas, UNAM, Mexico City, Mexico, 1981–4 |
| 1986–7 | Circulo de Bellas Artes, Madrid, Spain, 1986–7 |

Selected Solo Exhibitions

2011	Tate Modern, London, England
2010	*Gabriel Orozco*, Kunstmuseum Basel, Basel, Switzerland; Musée National d'art Moderne, Centre Pompidou, Paris, France
2009	*Gabriel Orozco*, Museum of Modern Art, New York
	Gabriel Orozco, Kurimanzutto Gallery, Mexico City, Mexico
2008	*Gabriel Orozco: Inner Circles of the Wall*, The Dallas Museum of Fine Art, Dallas, Texas
2006	*Gabriel Orozco*, Museo del Palacio de Bellas Artes, Mexico City, Mexico
	Museum Ludwig, Cologne, Germany
2005	Palacio de Velázquez, Museo Nacional Centro de Arte Reina Sofia, Madrid, Spain
	Marian Goodman Gallery, New York, New York
2004	*Photographs*, Hirshhorn Museum, Washington DC
	Gabriel Orozco, Serpentine Gallery, London, UK
2003	*The Weight of the Sun*, Douglas Hyde Gallery, Trinity College, Dublin, Ireland
	Museo de Arte Contemporaneo de Oaxaca, Oaxaca, Mexico
	CAV (Centro de Artes Visuais), Coimbra, Portugal
	Marian Goodman Gallery, New York, New York
2002	Marian Goodman Gallery, New York, New York
2001	Marian Goodman Gallery, New York, New York
2000–1	*Gabriel Orozco*, The Museum of Contemporary Art, Los Angeles, California; Museo Internacional Rufino Tamayo, Mexico City; Museo de Arte Contemporaneo de Monterrey, Monterrey, Mexico
2000	*Blue Memory*, Shima/Islands, Mirei Shigemori Residence, Kyoto, Japan
1999	Portikus, Frankfurt am Main, Germany
	Galerie Chantal Crousel , Paris
	Gabriel Orozco: Photogravity, Philadelphia Museum of Art, Philadelphia, Pennsylvania (Museum Studies 5)
1998	Marian Goodman Gallery, New York, New York
	St Louis Museum of Art, St. Louis, Missouri
	Centro Fotográfico Alvarez Bravo, Oaxaca, Mexico
	Clinton is Innocent ARC/Musée Nationale d'Art Moderne de la Ville de Paris, Paris, France
1997	*Recordings and Drawings*, Stedelijk Museum, Amsterdam, The Netherlands
	Staalichen Museum am Kulturforum, Berlin, Germany
	Centre de la Vieille Charité, Musées de Marseilles, Marseilles, France
1996	Kunsthalle Zürich, Zurich, Switzerland
	Institute of Contemporary Art, London, England
	The Empty Club, The Art Angel Project, London, England
	Marian Goodman Gallery, New York, New York
	Art Gallery of Ontario, Toronto, Ontario
1995	*Migrateurs*, ARC/Musée d'Art Moderne de la Ville de Paris, Paris, France
1994	Marian Goodman Gallery, New York, New York
	Gabriel Orozco, Museum of Contemporary Art, Chicago, Illinois
1993	Museum of Modern Art, New York, New York (Projects 41)
	Kanaal Art Foundation, Kortrijk, Belgium

Selected Group Exhibitions

2009 *Desenhos [Drawings]: A–Z*, Pavilhão Branco – Museu da Cidade, Lisbon, Portugal
A mancha humana / the human stain, Centro Galego de Arte Contemporánea (CGAC), Santiago de Compostela, Spain
Continuous Present, Yale University Art Gallery, New Haven, Connecticut

2008 *La Colección: La Tradición de la Rupturas*, Museo Arte Moderno, Mexico City, Mecico
Las Implicaciones de la Imagen, Colección Coppel MUCA, Mexico City, Mexico

2007 *Hidden in Plain Sight: Contemporary Photographs from the Collection* Metropolitan Museum of Art, New York, New York
La Planta, Arte Contemporáneo Omnilife, Guadalajara, Mexico

2006 *Super Vision*, The Institute of Contemporary Art, Boston
Universal Experience: Art, Life, and the Tourist's Eye, MCA, Chicago & Hayward Gallery, London, England
Part Object, Part Sculpture, Wexner Center for the Arts, Columbus, Ohio

2005 *Covering the Real: Arts and the Press Picture, from Warhol to Tillmans*, Kunstmuseum Basel, Switzerland
The Experience of Art, 51st Venice Biennale, Venice, Italy
Luna Park: Fantastic Art, Villa Manin Centro d'Arte, Codriopo, Italy
Bidibidobidiboo, Fondazione Sandretto Re Rebaudengo, Turin, Italy

2004–5 *Do You Believe In Reality?*: 2004 Taipei Biennial, Taipei, Taiwan
Monument to Now, Deste Foundation, Athens, Greece

2003 *Common Wealth*, Tate Modern, London, England
Work Ethic, Baltimore Museum of Art, Baltimore, Maryland; Des Moines Art Center; Wexner Center for the Arts, Columbus, Ohio
Ritardi e Rivoluzioni and Utopia Station, Venice Biennale, Venice

2002 *Tempo*, The Museum of Modern Art, New York
Documenta x1, Kassel, Germany
Public Affairs, Kunsthaus Zurich, Switzerland
Dialogos entredos mementos del arte Mexicano, Museo de Arte Moderno, Mexico city, Mexico
En Route, Serpentine Gallery, London, England

2001–2 *ARS 01*, Museum of Contemporary Art, KIASMA, Helsinki, Finland

2001 *Yokohama 2001: International Triennial of Contemporary Art*, Yokohama, Japan
Dévoler, Vivent les Frac (suite), Institut d'art contemporain, Villeurbanne, France

2000 *Let's Entertain*, Walker Art Center, Minneapolis, Minnesota

1999 *La Ville, Le Jardin, La Mémoire*, Villa Medici, Rome, Italy
SITE Sante Fe Biennial, Looking for a Place, Sante Fe, New Mexico
Carnegie International, Carnegie Museum of Art, Pittsburgh, Pennsylvania
La Casa, il corpo, il cuore, Museum Moderner Kunst Stiftung Ludwig Wien, Vienna, Austria

1998 Berlin Biennial, Berlin, Germany
São Paulo Biennial, São Paulo, Brazil

1997 *Skulptur. Projekte in Münster '97*, Münster, Germany
Documenta x, Kassel, Germany
Whitney Biennial, Whitney Museum of American Art, New York, New York

1996 *Gabriel Orozco, Rirkit Tiravanija og*, The Living Art Museum, Reykjavik, Iceland
Inside – Out (Inaugural Exhibition), Museum of Contemporary Art, La Jolla, California
Kwangju Biennial, Seoul, Korea
Das Americas, Museum of Art São Paulo, São Paulo, Brazil
Where is Abel Thy Brother?, Zacheta National Gallery of Contemporary Art, Warsaw, Poland

1995 *Réalité Décalée*, Fonds Régional d'Art Contemporain Bretagne, Châteaugiron, France

1994 *Watt*, Witte de With & Kunsthal, Rotterdam, The Netherlands
The Epic and the Everyday: Contemporary Photographic Art, Hayward Gallery, London, England
Lo crudo y lo cocido, Museo Nacional Centro de Arte Reina Sofia, Madrid, Spain

1993 *Summer Group Show*, Marian Goodman Gallery, New York, New York
Real Time, Institute of Contemporary Arts, London, England
Aperto '93 :Emergenza/Emergency, 45th Venice Biennial, Venice, Italy
In Transit, The New Museum of Contemporary Art, New York, New York

1992 *Si Colón Supiera!...*, Museo de Monterrey, Monterrey, Mexico
América. Bride of the Sun, Koninklijk Musuem voor Schone Kunsten, Antwerp, Belgium

1991 *Another Mexican Art*, Pasadena Art Center, Pasadena, California
Cuerpos Encontrados, Museo de la Alhóndiga de Granaditas, Guanajuato, Mexico

1990 *Installations: Current Directions*, Museum of Contemporary Hispanic Art, New York, New York
Video D.F., Bronx Museum of the Arts, New York, New York

1989 *A Propósito*, Museo del Ex-Convento del Desierto de los Leones, Mexico City, Mexico

1987 Salón Nacional de Artes Plásticas, Secció Espacios Alternativos, Museo de Arte Moderno, Mexico City, Mexico

1985 *Sin Motivos Aparentes I*, Museo Carrillo Gil, Mexico City, Mexico

1984 *Neográfica*, Museo Universitario del Chopo, Mexico City, Mexico

1983 Salón Nacional de Artes Plásticas (drawing section), Instituto Nacional de Bellas Artes, Mexico City, Mexico

Select Bibliography

2009 *October Files: Gabriel Orozco.*
Bois, Yve-Alain, ed. Cambridge,
Massachusetts.
Gabriel Orozco. Temkin, Ann, Anne
Byrd, Benjamin H.D. Buchloh, Briony
Fer, Paulina Pobocha. New York, NY:
Museum of Modern Art.

2006 *Gabriel Orozco.* Godfrey, Mark, Philip
Hoare. London, England: Jay Jopling/
White Cube Publications.
Gabriel Orozco. Orozco, Gabriel,
Yve-Alain Bois, Benjamin H.D. Buchloh
and Briony Fer. Mexico City, Mexico:
Museo del Palacio de Bellas Artes.
Gabriel Orozco: Samurai's Tree Invariant.
Sabau, Luminita. Cologne, Germany:
Verlag der Buchhandlung Walther König.

2005 *Gabriel Orozco.* Orozco, Gabriel,
Guillermo Santamarina and Marta
González Orbegozo. Madrid, Spain:
Museo Nacional Centro de Arte Reina
Sofia.
*Gabriel Orozco en Villa Iris: Taller y
exposicion.* Fundacion Marcelino Botin,
July.
Textos sobre la obra de Gabriel Orozco.
Birnbaum, Daniel and Gabriel Orozco.
Mexico City, Mexico: Conaculta / Turner
Publicaciones S.L.

2004 *Gabriel Orozco.* Orozco, Gabriel,
Briony Fer, Benjamin H. D. Buchloh
and Rochelle Steiner. London, England:
Serpentine Gallery.
Gabriel Orozco: Photographs. Orozco,
Gabriel, Phyllis D. Rosenzweig and Mia
Fineman. Washington, DC: Hirshhorn
Museum and Sculpture Garden /
Gottengin, Germany: Steidl Publishers.
Landscape and Memory. Madrid, Spain:
Obra Social.
*Latin American & Caribbean Art: MoMA
at El Museo.* Basilio, Miriam. New York,
New York: El Museo del Barrio and The
Museum of Modern Art.

2003 *Common Wealth.* Morgan, Jessica.
London, England: Tate.
Gabriel Orozco: Trabajo. Orozco, Gabriel
/ Galerie Chantal Crousel. Cologne,
Germany and Paris, France: Galerie
Chantal Crousel.
*Of Games, the Infinite and Worlds: The
Work of Gabriel Orozco.* González,
Miguel Virgen, Gabriel Orozco and
John Hutchinson. Dublin, Ireland: The
Douglas Hyde Gallery.

2001 *Gabriel Orozco: From Green Glass to
Airplane Recordings.* Orozco, Gabriel,
Martijn van Nieuwenhuyzen and Gijs

Stork. Amsterdam, The Netherlands:
Stedelijk Museum / Artimo Foundation.

2000 *Gabriel Orozco.* Benjamin H.D. Buchloh,
Alma Ruiz and Gabriel Orozco. Los
Angeles, California: The Museum of
Contemporary Art.
Gabriel Orozco [Postcard Book]. Orozco,
Gabriel. Los Angeles, California:
Museum of Contemporary Art.

1999 *Gabriel Orozco: Chacahua.* Orozco,
Gabriel and Daniel Birnbaum. Frankfurt
am Main, Germany: Portikus.
Photogravity. Orozco, Gabriel and Ann
Temkin. Philadelphia, Pennsylvania:
Philadelphia Museum of Art.

1998 *Gabriel Orozco: Clinton is Innocent.*
Orozco, Gabriel / Musée d'Art Moderne
de la Ville de Paris. Paris, France: Paris
Musées.

1996 *Empty Club.* Orozco, Gabriel, James
Lingwood, Jean Fisher, Mark Haworth-
Booth and Guy Brett. London, England:
Artangel.
Gabriel Orozco. Orozco, Gabriel,
Bernhard Bürgi, Bettina Marbach
and Benjamin H.D. Buchloh. Zürich,
Switzerland: Kunsthalle Zürich.

1995 *Cocido Y Crudo.* Balseiro, Maria Luisa
and Martin Smith. Madrid, Spain: Museo
Nacional Centro de Arte Reina Sofía:
pp.146–7, 262–3.
Options 47: Gabriel Orozco. Orozco,
Gabriel. Chicago, Illinois: Museum of
Contemporary Art.

1993 *Gabriel Orozco.* Orozco, Gabriel and
Benjamin H.D. Buchloh. Kortrijk,
Belgium: The Kanaal Art Foundation in
association with La Vaca Independiente.
Gabriel Orozco: Projects 41. New York,
New York: The Museum of Modern Art.

1992 *America Bride of the Sun.* Bucher,
Bernadette J. / Koninklijk Museum voor
Schone Kunsten. Brussels, Belgium:
Flemish Community, Administration of
External Relations: p.338.

Photo credits

Copyright